Switch
to
Digital

Switch to Digital

Discover the exciting world of digital photography!

William Cheung

Argentum

First published 2004 by Argentum, an imprint of Aurum Press Ltd, 25 Bedford Avenue, London WC1B 3AT

Book packaged by emergingART publishers
www.emergingart.co.uk

A catalogue record for this book is available from the British Library

ISBN 1 902538 36 6

1	2	3	4	5	6	7
2004	2005	2006	2007	2008	2009	2010

Printed and bound in China

Contents

Switch to Digital Imaging Gallery

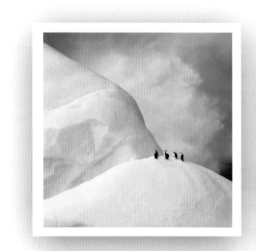 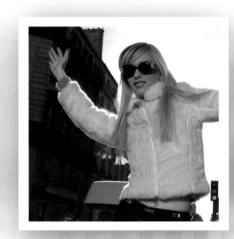

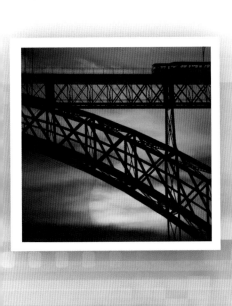

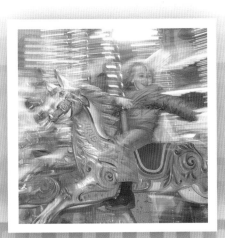

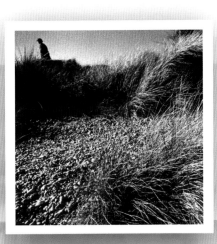

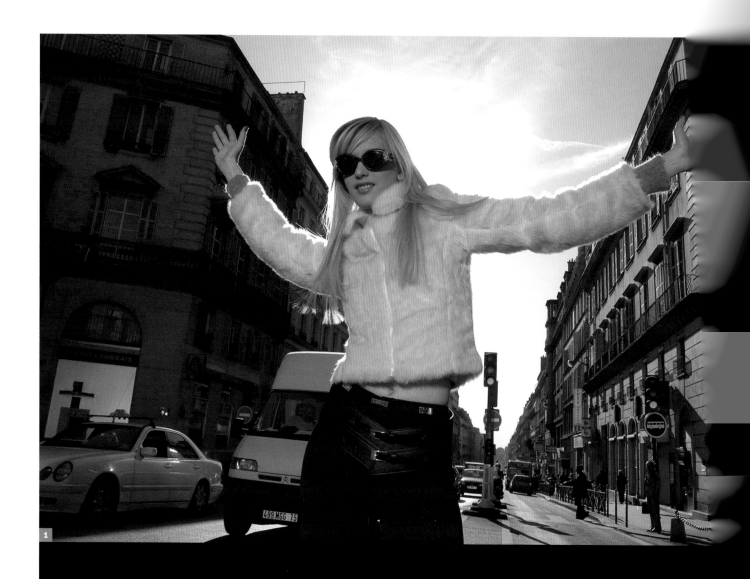

Gallery

Digital imaging gives the photographer a powerful set of creative tools with which to enhance their picture taking experiences.

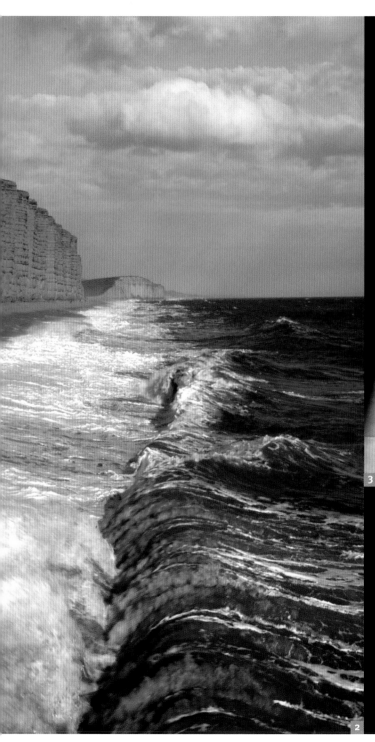

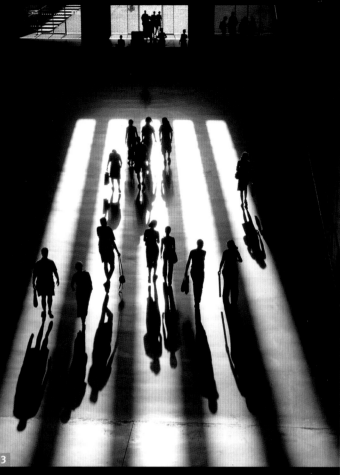

1 Standing in the middle of a Parisian street meant I had little time to work. I did not even bother with a meter reading and just took pictures and checked the results on the digital camera's monitor. A couple of test shots was all that was needed.

2 Landscape pictures often benefit from the application of the rule-of-thirds. You can see how this coastal shot conforms to the rule for a lovely, balanced composition.

3 Many scenes are much more effective in black & white than in colour. You may or may not appreciate this at time of taking the shot, but digital gives the option of exploring both before deciding.

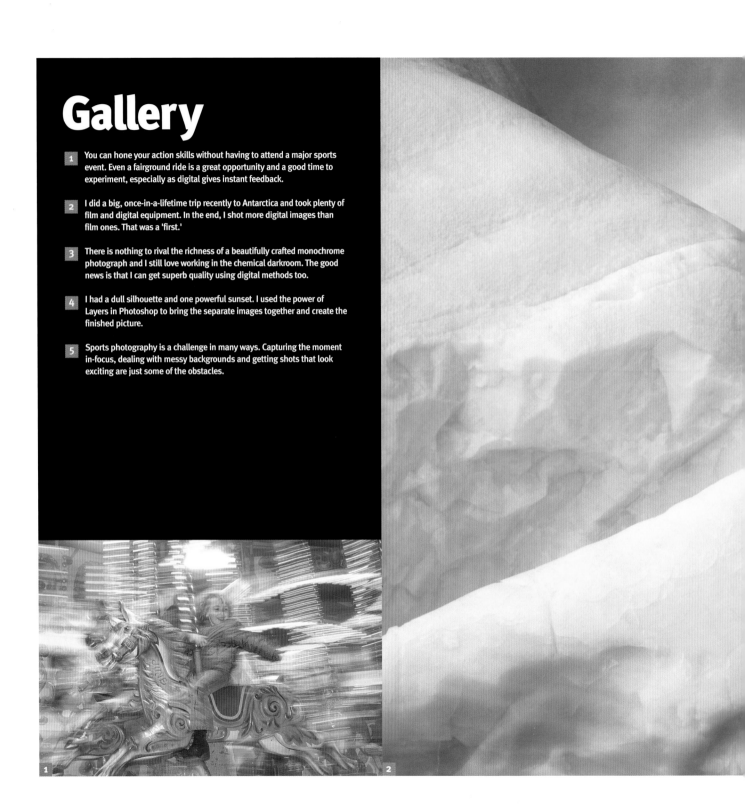

Gallery

1 You can hone your action skills without having to attend a major sports event. Even a fairground ride is a great opportunity and a good time to experiment, especially as digital gives instant feedback.

2 I did a big, once-in-a-lifetime trip recently to Antarctica and took plenty of film and digital equipment. In the end, I shot more digital images than film ones. That was a 'first.'

3 There is nothing to rival the richness of a beautifully crafted monochrome photograph and I still love working in the chemical darkroom. The good news is that I can get superb quality using digital methods too.

4 I had a dull silhouette and one powerful sunset. I used the power of Layers in Photoshop to bring the separate images together and create the finished picture.

5 Sports photography is a challenge in many ways. Capturing the moment in-focus, dealing with messy backgrounds and getting shots that look exciting are just some of the obstacles.

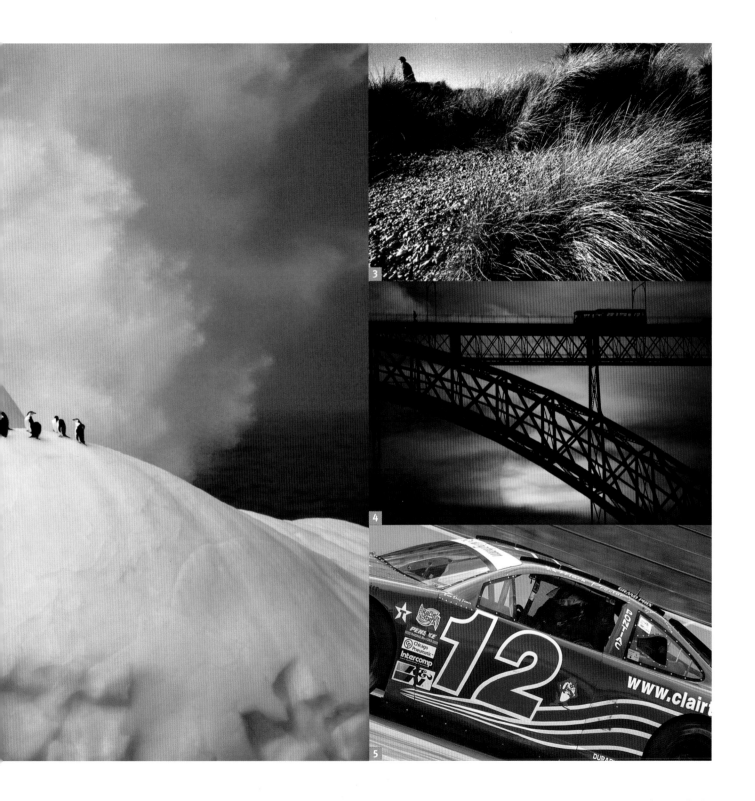

Gallery

1 Any time of day or night, inside or out, old or new, buildings are wonderful subjects. A wide-angle lens was used to capture this striking interior image of a building in Berlin.

2 Zoos can offer great photo opportunities but you need to look around for the best camera angles to avoid messy backgrounds and to throw any caging or bars out of focus. A 300mm lens was used to capture this tiger.

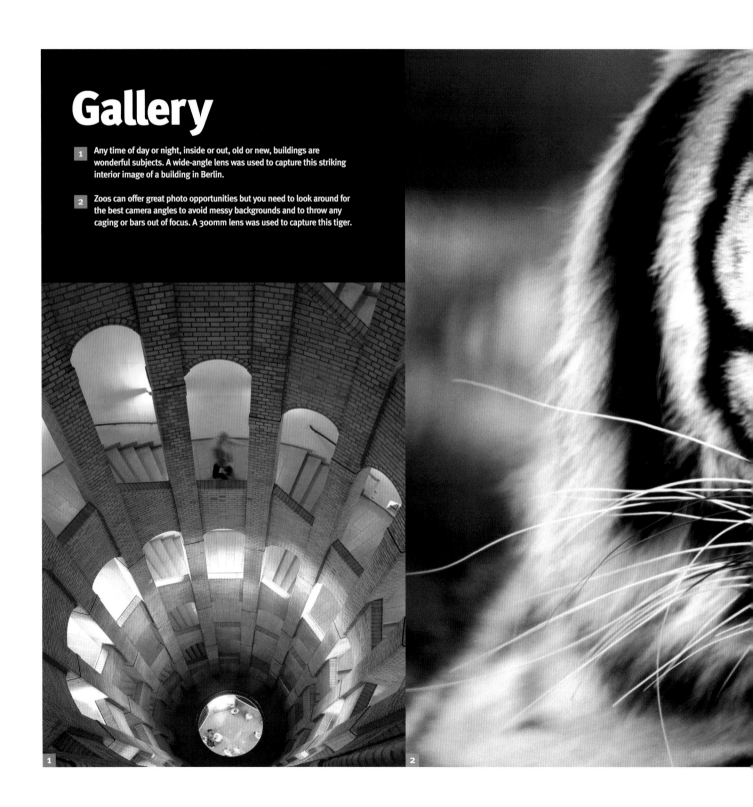

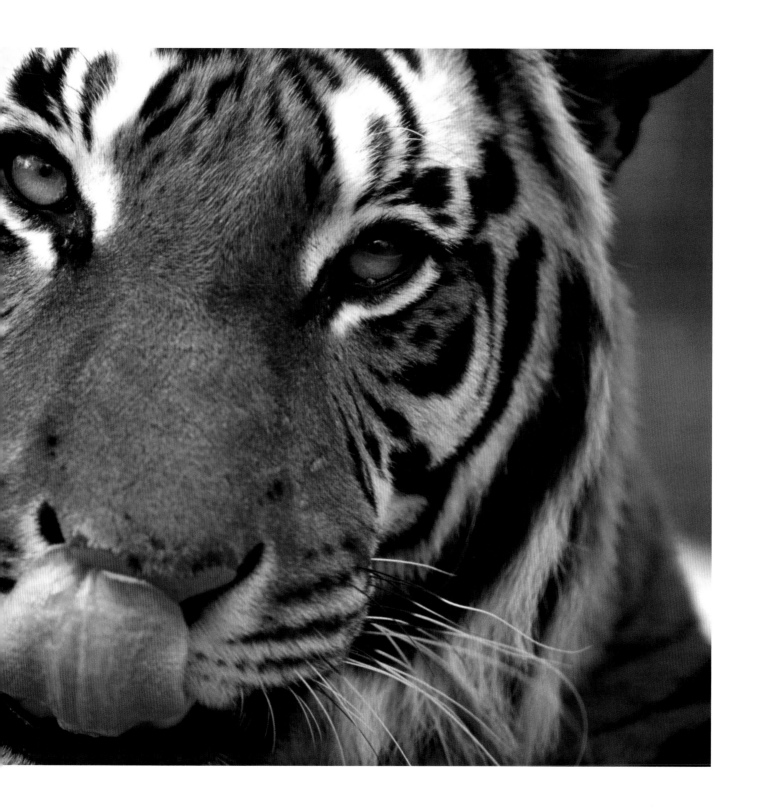

1 Choosing the right gear

Film versus digital

Photography has been around for over 160 years yet it has probably moved forward and touched more people in the past five years than ever before.

As digital cameras and imaging have evolved, the word 'versus' used in the film or digital context, has become increasingly irrelevant because it implies that it is a head-on battle from which one will emerge victorious. I guess the film or digital debate will never totally go away, but where attitudes have changed is that photographers are now looking positively at what digital can do for their photography and how it can mesh in with their film work.

I reckon that is where I am and in my view, the only victor is photography and we photographers now have more options in taking, making and storing pictures than ever before.

Great pictures are great pictures whether they are on film or digital and getting embroiled in comparisons of megapixels and resolving power only detracts from what we should all be aiming for, namely creating great pictures.

In short, I think it is time to be thankful because we have never had it so good.

Film users continue to have the pick from a huge array of products including many specialist items like toners, film developers and so on. Of course, in time some options might go but this will not happen overnight.

For digital photographers, the astounding rate of progress shows no sign of abating yet. Cameras continue to gain resolution, computers are getting faster and software is getting ever more powerful.

These are tremendously exciting times and I have set out accordingly to make the best of both worlds. Digital and film are not mutually exclusive. On the contrary, in tandem they offer a huge opportunity.

I still love film and shoot lots of it, especially black & white and I am frequently in my smelly 'wet' darkroom making fibre prints. I remain a dedicated slide film user but whereas I used to store the originals in a filing cabinet, I now archive the best images by scanning them and storing them on CD and DVD. Furthermore, where I used to make the odd chemical colour print, inkjet printing means I make lots of prints.

Naturally, I have a digital camera as well as all the gear for a digital 'darkroom'. This means a computer with CD and DVD rewriter, scanners, inkjet printers, a graphics tablet and external hard drives.

The end result of all this is that I am taking more pictures than ever before and enjoying photography more now than for years. And I am doing more with the results. Making prints is one thing but I, along with millions of others, have my own website. You will find it at www.williamcheung.co.uk

In short, with all this technology at our disposal our pictures can have a life and an audience that was impossible previously.

However, with all these new opportunities and rapidly evolving technology come lots of problems as well as the need to learn. I hope Switch to Digital will help you in the learning process.

Media types

Digital cameras record images on media or storage cards. As yet, no 'standard' format has been adopted and used by all the camera manufacturers. In time, that might change but meanwhile, these are the media cards in current use.

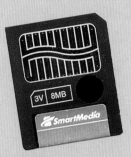

SmartMedia

Once a very common card format, but limitations on capacity and operating speed means its popularity is in serious decline and we are unlikely to see any more new cameras using this format.

x-D

This is the newest of the formats and the cards are really tiny but have the potential of huge capacity. Developed by Fuji and Olympus and adopted by many more manufacturers, cards of 4GB and more are said to be possible.

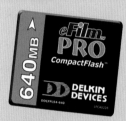

CompactFlash

This very popular storage format is available in two variants. Most cameras, readers and storage devices will accept both but some devices accept only Type 1, so this is a point to check. Type 1 is flash memory so there are no moving parts and fast write speeds are possible. Cards of up to 1GB are available. The Type II CompactFlash card is the Microdrive. Developed by IBM, this is a tiny hard drive so is potentially less reliable than Type I cards.

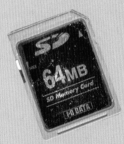

Secure Digital (SD)

A storage type sometimes known as MMC (Multimedia card) and is used in personal organisers and MP3 music players as well as cameras. This is a popular format among digital compacts.

MemoryStick

A storage format developed and championed by Sony. It is used in their digital cameras, PDAs and camcorders. In addition to the standard MemoryStick there is also a professional format with more capacity.

The digital compact

The digital compact is easy to use and the perfect take-everywhere companion, which makes it a perfect visual diary.

Compact cameras outsell any other camera type because they are so conveniently small and simple to use. Yet to dismiss them as gadgets of convenience would be underselling them. Packed with features and sporting first-class optics, there is no doubt that the latest digital compacts are seriously capable tools.

In the world of digital photography, there are also a great many compacts that are novelties or introduced as fashion statements where form triumphs over function. This has widened the appeal of photography and that, ultimately, can only be a good thing.

Look at a more typical (if there is such a thing!) digital compact camera and you will find a long list of appealing features.

Just as with SLRs, it is the camera's resolution that most prospective purchasers will look at first.

In practice, the lowest resolution suitable for making snapshot sized prints is two megapixels. Move up the evolutionary ladder and there we see three and four megapixel cameras. Advanced models are highly featured and used with care in a fine quality image setting, such cameras are readily capable of 10x8in and A4-sized prints of genuine photographic quality.

Digital compacts come in different shapes and sizes, from the truly pocket-size upwards.

All about resolution & print sizes

One of the most asked questions by digital newcomers is 'how big a print can I get from a so-and-so resolution camera?' There is no real answer because you can get a poster-size print from any file size, although the quality might be dreadful.

The table below should help. A print made from an image with a resolution of 200ppi is high quality and is perfectly acceptable but 300ppi gives true photo quality. The table assumes no image resampling (known as interpolation) in software.

Megapixels	Resolution	Print size at 200ppi	Print size at 300ppi
1.2	1260 x 960	6.3 x 4.8in	4.2 x 3.2in
1.9	1600 x 1200	8 x 6in	5.3 x 4in
3.1	2048 x 1536	10.2 x 7.6in	6.8 x 5.1in
3.9	2288 x 1712	11.4 x 8.5in	7.6 x 5.7in
4.9	2560 x 1920	12.8 x 9.6in	8.53 x 6.4in
6	3000 x 2000	15 x 10in	10 x 6.6in

Resolving power

In terms of resolution at least, the highest resolution among compact cameras is eight megapixels, and high quality prints of A3-size are within easy reach. Such cameras are aimed at the keener photographer and, as you would expect, are among the most expensive. See the chart opposite to see how resolution and print size are related.

Resolution is one feature among many and while it is very important, there are others also worth considering. Regarding automatic focusing and automatic exposure systems, there is not a great deal to choose between systems from the various makers. Personally, the features I would look at the closest are the lens and camera handling.

By lens, I am referring more to the 'range' of the lens as opposed to any particular brand. Actual lens focal length will not mean a great deal to most people, which is why manufacturers quote a focal length equivalent to the 35mm film format, which more people understand. More frequently, the lens is expressed as a range, ie 2x, 3x or 4x. This simply means that the focal length at the long end is twice, three times or four times that at the short end. Obviously, the wider the zoom range the greater the potential versatility in terms of picture-taking situations.

By 'handling' I mean not just how the camera's controls physically perform but also their use in terms of positioning and size. Some digital cameras are so small that tiny controls are inevitable and that might not suit you. The only real way to find out how a camera handles is to use it, but taking your time at the buying stage will undoubtedly help.

Digital compacts are much more versatile than many people give them credit for. This shows how close you can get with a camera's macro or close focusing feature.

Compacts are perfect for those grab shots when you might not have an SLR with you. I spotted Lord Snowdon at an exhibition of his work and asked him if I could quickly snap him with his work as a great backdrop.

The digital SLR

For the ultimate picture-taking versatility, there is nothing to beat the digital single-lens reflex camera.

The digital SLR (single-lens reflex) is bigger, heavier and more expensive than a digital compact camera. But these disadvantages are easily outweighed by the incredible versatility such cameras offer.

The SLR has an optical system comprising a mirror and pentaprism that provides an image directly from the lens so, broadly speaking, what you see in the viewfinder is what you get in the final picture. By comparison, the compact has a viewing system that is separate from the taking lens.

The SLR category can be subdivided further into the SLR with lenses that are fixed and cannot be changed, and the true system camera, the interchangeable lens SLR.

Over the years, the fixed lens SLR has been variously known as the bridge, hybrid or the all-in-one camera. The latter is the most accurate because in one compact body there is reflex viewing for accurate composition, a generous array of features and a single zoom lens that is perfect for many picture-taking situations. Such cameras suit photographers of all levels and are rightly popular.

Ultimate control

You might think that if an all-in-one camera is so great that there would be no market for interchangeable lens SLR cameras. But that is not the case and it is the interchangeable lens SLR that I want to concentrate on here.

The huge breadth of lens options is one major benefit but so too is the handling and versatility offered by such cameras. For example, a typical digital SLR will have

Digital SLR cameras are feature-packed and the option of interchangeable lenses allows great flexibility.

SLR cameras incorporate a complex reflex viewing system which gives through-the-lens viewing. In practice, this means very precise compositions are possible, an important consideration for experienced photographers.

File formats

Digital camera images can be saved to the storage media in different formats and which format you use is fundamental, so do think about this.

Three formats are used: JPEG (.jpg), TIF (.tif) and RAW (suffix depends on the manufacturer). **JPEG** A format named after the Joint Photographic Experts Group, which developed this commonly used standard. This is a 'lossy' format so data from the image is lost each time an image is saved as a JPEG.

On the plus side, the JPEG algorithum compresses files to smaller sizes than 'lossless' formats and a range of compression ratios is available.

TIF This stands for Tagged Image File Format. This format is lossless so as you open and close TIF files no data is lost and image quality remains constant. The downside of this is that file sizes are bigger, even with LZW lossless compression.

RAW RAW files contain all the data direct off the sensor without any in-camera processing. In effect, they are digital 'negatives'. Files are relatively large and need to be 'processed' or converted in suitable software to JPEG or TIF format before further work is possible in image editing programs. Adobe Photoshop CS has a RAW converter built-in.

features to allow linking up with studio flash, to let you shoot quality files at a comparatively rapid rate and be at the centre of an enormous accessory system to cope with almost every form of photography imaginable. It is also true that SLRs are more robust and solidly engineered compared with a typical all-in-one SLR so it is able to withstand heavy use.

For many photographers, it is the interchangeable lens option that is key. I love being able to switch quickly from a macro lens to a very wide-angle or long telephoto and get shots I simply could not have got otherwise. But even if I did my shooting with a standard lens, there is something fulfilling and reassuring about using a full-blown SLR.

So far, only one digital SLR system has been truly designed from the ground up and that is Olympus E-1. All the other models slot into systems and accept existing lenses and accessories. There are pros and cons of each concept. A completely new system means users have to invest heavily in lenses and accessories, while on the plus side everything is designed to work in perfect harmony for optimum performance. SLRs that fit into existing systems mean there is less investment required for current system owners but performance can be compromised. The theory goes that lenses designed for film cameras do not perform at their best when used with a digital sensor. The theory is one thing and the reality something else and it is fair to say that most people, myself included, will be perfectly happy with the results.

Sensor sizes

More important is how lenses designed for 35mm format work with digital SLRs. The sensor inside most digital SLRs is smaller than the 35mm format, and fitting a conventional lens onto such cameras effectively gives a magnifying effect, usually in the order of 1.5x. Thus, fitting a 200mm lens on a digital SLR gives a telephoto equivalent of 300mm. Wildlife and sports photographers will appreciate this.

It is at the wide-angle end that this magnifying effect has disadvantages. For example, a 20mm ultra wide-angle lens fitted onto a digital SLR has the effect of a much more modest 30mm lens. For lovers of extreme wide-angle effects this is a serious drawback and one that the lens makers have only recently come to terms with. Lens with focal lengths as short as 12mm and 14mm are now available for wide-angle lovers.

Lenses are so important that you will not be surprised to learn that there is much more about lenses and their use in this book.

Of course, if a digital sensor is the same size as the 35mm film format, the pictorial effect would be identical. There is no doubt that photographers everywhere would welcome digital SLRs with full-size sensors, but so far their prohibitive cost and the technical obstacles involved have restricted their emergence to a few bulky models at the professional end of the market.

In time, this might change and full-frame digital SLR cameras might be as cheap and as compact as a typical film SLR of today. But there is the feeling that the quality possible with such big sensors and the resulting large file sizes is not needed by most users.

Setting up

You probably do not need telling that digital cameras are incredibly versatile. But with so many options and features, setting them up correctly is important.

To make the most of a digital camera it needs to be set up correctly. There are many more options on a digital model compared with a film camera and the chances of getting things wrong are much greater. Get to learn the many options available on the camera's menu.

Drive mode

Most times, shooting one frame-per-second is fine, but occasionally you may want to take a couple of shots in quick succession. Because of this, my default mode is continuous shooting and I just take my finger away for one shot, or leave it pressed on the shutter release for more.

The self-timer feature often comes under the drive menu. Most give a set delay of, say, 10 seconds before taking a shot but you might be able to adjust the time delay. A shorter delay is handy when using the self-timer as a way of remote release.

Exposure modes

■ PROGRAM AUTOEXPOSURE (AE)
The camera sets both the aperture and shutter speed for the lighting conditions. This is the most convenient mode to use but do keep an eye on the camera's chosen settings.

■ APERTURE-PRIORITY AE
The user chooses the aperture and the camera sets the shutter speed to suit. This is a popular exposure mode and it is my personal favourite.

■ SHUTTER-PRIORITY AE
The user chooses the shutter speed and the camera sets the aperture to suit. An ideal mode for subjects like action where knowing the set shutter speed is important.

■ MANUAL
The user sets both aperture and shutter speed using the camera's meter indications. If you like to take control, this is the mode to use.

■ SUBJECT-BASED MODES
The camera sets aperture and shutter speed to suit, for example, landscape, portrait or close-up modes. Convenient and great for less experienced photographers.

Sensitivity

This is the digital equivalent to ISO film speed. The slower the ISO speed the better the image quality, with smoother tones, richer colours and less noise. Set the sensitivity that will allow a shutter speed fast enough for shake-free pictures. In normal daylight, an ISO of 100 or 200 is fine.

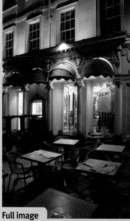
Full image

ISO 200

ISO 400

ISO 800

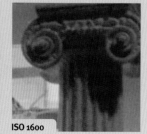
ISO 1600

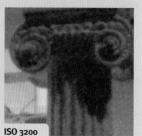
ISO 3200

White balance

Different light sources have different colour temperatures and this is why a camera set to daylight balance or loaded with daylight film will give orange-looking pictures in tungsten lighting. Of course, digital cameras are equipped to deal with different lighting types so leaving it on the automatic white balance setting is perfectly sensible. On reviewing the image, however, if you do not like its interpretation of the lighting's 'colour' manually setting the white balance is worth considering. In this instance, set the tungsten or incandescent setting, usually indicated by a light bulb symbol.

It is also worth experimenting with colour balance settings. For example, I find that on bright days I prefer to use the cloudy setting for 'warmer' looking pictures rather than going for the sunlight setting.

If you shoot in the camera's RAW format setting, it does not matter which colour balance setting has been chosen because you can decide this during the RAW conversion process in software. Such creative flexibility is another reason why shooting in this format is something you should consider.

Custom functions

Scroll through the menus on most digital cameras and you will probably be staggered by the amount of custom features on offer. There is simple stuff like turning off the warning beep or changing auto power off from one to five minutes, but there is usually lots of creative stuff to exploit. The ones I like to explore are those concerning aspects of handling. The maker's basic set-up often does not suit the way I prefer to work and custom functions let you tailor the camera to suit.

File size

Digital cameras offer several image quality modes. For the best quality, set RAW (if your camera has it) or Fine TIF mode. These files consume the most storage space, but for serious shooting these are the modes to use and allow big prints to be made without much quality loss. For general use, Fine or Large JPEG quality is fine, plus they write quickly and take up less space on the storage card. Fine for A4 prints and larger.

For e-mail and web shooting, normal or basic shooting is fine. Higher compression and smaller image sizes means you get the most number of shots on the storage media but and it is still possible to get photo quality small prints.

Full image

Small fine JPEG

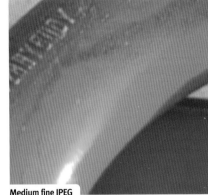
Medium fine JPEG

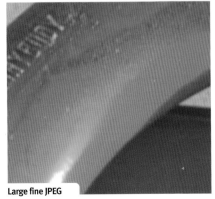
Large fine JPEG

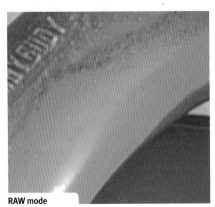
RAW mode

Camera accessories

There are a huge number of accessories and gadgets that will help you make the most of your digital camera. Here is a short-list of gear that I consider essential.

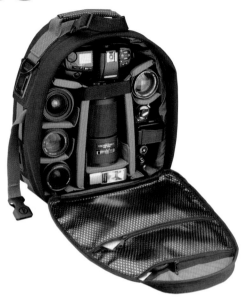

Camera filters

Photographers have always loved enhancing and modifying their pictures with on-camera filters. However, some filters have been made redundant because the effects can be replicated digitally. For example, soft-focus, graduated and warm-up effects can be applied in software. This freedom does mean you no longer have to carry filters with you and can apply the effects retrospectively.

The effect of some popular filters, however, cannot be replicated so convincingly in software. The most notable of these is the polariser. The multi-talented polariser does several jobs. One, it cuts down reflections off water, glass and painted surfaces. Two, it cuts glare and so in effect saturates colours. Three, it eliminates polarised light and so enriches blue skies. Four, because the polariser

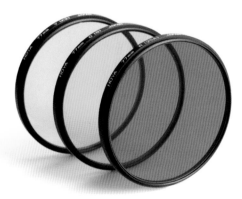

absorbs around two stops of light, it can also be used as a neutral density filter.

Two polariser types are available: circular and linear. This is not a reference to the filter's physical shape but to the way the filter is constructed. The circular polariser is necessary for the correct operation of SLR cameras with autofocus and spot/selective metering systems. Linear polarisers are fine for manual focus and SLRs with centre-weighted metering systems.

Bags and rucksacks

Whether you own a compact camera or a decent-sized SLR system, you will need a bag to carry your kit and to keep the various bits-and-bobs to hand whenever you are out.

Bags come in a number of sizes and styles, from belt pouches for compacts to heavy cases on wheels. Bags are the sort of accessories that photographers accumulate over the years, which explains why I have several to choose from.

I have a large pouch, which is perfect for carrying a camera 'just in case.' It will take an SLR and lens with room for a few rolls of film or extra cards and batteries.

When I am out and expecting to be taking pictures, I have the choice of two bags big enough for a couple of cameras and three

lenses while still having room for film, filters, cards and batteries. One bag is an off-the-shoulder model, which I prefer for use around town, and the other is a photographic rucksack, which is great for longer walks. It is more comfortable and means my hands are free, but getting kit out is slower.

Camera supports

Camera shake is a major cause of unsuccessful pictures, so a support of some sort is important. Shake can occur with all lens types but there is an extra risk with long telephotos with small maximum apertures. It is easy to be lured into thinking that handholding is fine, but it is not advised if you want the best possible image sharpness.

There is also a creative reason why a tripod is worth using, namely it gives you freedom with aperture and shutter speed choice.

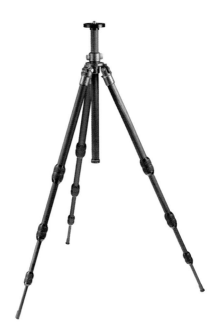

Camera supports come in many forms. Tripods give the maximum support, although not all tripods do what they are supposed to do. For specific qualities to look for when choosing one, see page 75.

On the downside, tripods are slow to use and full-sized models are a pain to carry around. Although expensive, if you want a tripod that is light enough to be carried around all day, consider a carbon-fibre model.

Small mini or pocket tripods are also available. These are compact enough to be left in the gadget bag at all times and are fine used within their limits.

The monopod is a portable alternative to the tripod. It might not give ultimate stability but it is perfect for many forms of photography, including action, because of its portability.

Suction clamps, grips and beanbags are other gadgets that can offer support in different situations, and they all have their uses. For example, a beanbag is perfect if you are shooting out of a car window.

What else to pack

Spare batteries

Digital cameras are power-hungry so spare batteries are important. However, it is also true that the manufacturers have been working hard on this and the situation is changing. If your camera is still eating its way through batteries, buy a couple of sets of high capacity Nickel Metal Hydride (NiMH) rechargeable cells and a recharging unit than can be plugged into the car's cigarette lighter socket as well as the mains. If you do a great deal of location shooting, it is worth considering the option of a separate battery pack. This is a high capacity rechargeable cell that supplies energy to the camera via a cord. The pack itself can be attached to the camera or tucked away in a convenient pocket.

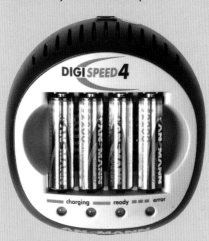

Remote release

Allows hands-free operation of the camera so helps avoid shake and movement during long exposures and macro photography.

Cleaning cloths and blower brush/CO_2 duster

I use micro-fibre cloths for keeping lenses and filters sparkling clean while the blower brush/CO_2 duster is great should you need to clean the sensor of the digital SLR. To be honest, this is not the sort of procedure you want to perform outdoors.

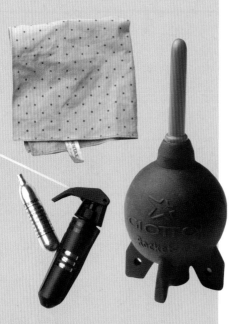

Multi-tool

I am not suggesting you can repair your camera with one, but a screw or something on the tripod leg might work loose.

Lenses

Which focal length lens you use has a profound impact on the composition so make sure you choose wisely.

Your camera is nothing without a lens. It is the lens that captures those rays of light and focuses them down onto the camera sensor to form the image. It stands to reason, therefore, that the focal length you choose and how you use the lens are vital aspects of camera technique that need mastering.

Compacts and all-in-one SLR cameras have an integral lens that cannot be exchanged, but as most have wide-ranging zooms this is not a problem.

With true SLRs and the option of interchangeable lenses, the creative potential is enormous even for those who have to work within a limited budget.

Which focal length you decide to use on a scene depends on how you want to interpret it. Confront two photographers with the same scene and one will take a few steps back and fit a telephoto, the other will walk closer and slip on a wide-angle. There are few definitive 'rules'.

I mention wide-angle and telephoto here as if they are two separate lenses. Of course, that might be the case, but with modern zoom lenses both wide-angle and telephoto effects can be achieved with the same lens. A zoom lens for the SLR can encompass focal lengths from 28mm wide-angle to 300mm telephoto and even a top-end all-in-one will have a 28-200mm lens.

Focal lengths explained

I need to explain the context of how the actual focal lengths are used not just in this book, but in magazines, by shop assistants and by the manufacturers themselves.

Ten tips for making the most of lenses

■ Protect the front lens element by fitting a high quality skylight or ultraviolet filter.
■ Poor quality filters (or too many filters used in tandem) will degrade image sharpness.

■ Whenever the lenses are off the camera, use the front and back caps to keep out dust.
■ Keep lenses clean to minimize flare and to optimise image quality. The rear element needs to be kept clean too.
■ Lenses give their best optical performance at mid-aperture values, say f/8 or f/11.
■ Make sure focusing is accurate. It sounds obvious but a slight misjudgement means the final result will be poor and you might blame your lens.
■ Use a lens hood. Light striking the front surface of a

lens can cause flare, which degrades the image.
■ Buy the best quality lenses you can afford. Like many things in life, the more you pay the more you get.
■ Use a camera support or shoot at fast shutter speeds to avoid camera shake.
■ Set a sensitivity that will allow a shutter speed fast enough for shake-free pictures. Sensitivity is the digital equivalent to film speed, so use the slowest ISO speed for the lighting conditions for the best image quality.

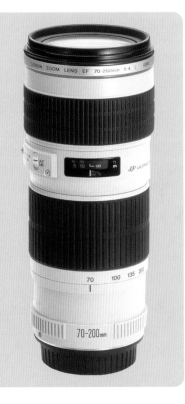

A digital compact, for example, may have a zoom lens with a focal length of 9-21mm. A figure of 9mm means little to most people. However, if that focal length is said to have an effect that is similar to a 28mm lens in the 35mm film format, it makes more sense. So, just bear in mind that the figures used here refer to the pictorial effect as opposed to the actual focal length.

There is another aside relevant to digital SLRs. Currently, there are few with a sensor that is the same size as the 35mm film format. For those that do, the lenses have exactly the same effect. However, there are more digital SLRs that have sensors smaller than the full 35mm frame and there is an effective increase in magnification in the order of 1.5x or 1.6x. Thus a 100mm lens on a digital SLR has a focal length of 150mm or 160mm respectively.

A good outfit
Everyone's idea of the perfect lens outfit differs because we all have individual styles and different interests. Generally, however, an outfit that will cater for most styles of photography would extend from 24mm wide-angle to 300mm telephoto. That range can be

A long telephoto lens is essential for shooting wildlife. This was taken on a 100-400mm zoom at the 400mm end, equivalent to 640mm on the Canon digital SLR used.

covered by two zooms, say a 24-70mm and a 70-300mm. Add a 100mm macro lens for close-up work and this is a three lens outfit ready to cope with most subjects. This outfit is also a foundation on which to build. If your interest deepens in sports photography you can add a zoom that extends out to 400mm or 500mm lens later.

Owning a set of great lenses is one thing, using them effectively is another. Regular shooting and practice certainly help.

Storage on the move

With digital shooting comes new challenges, and that is certainly true when it comes to looking after your images. We start with short-term storage here.

In some ways, life was easier with film. Finish a roll and it was put aside for processing and the camera reloaded ready to take more pictures. Digital photography is similar. Fill a storage card and it is easy enough to swap it for an empty one and to carry on shooting.

But there any similarities end. For one thing, with an exposed film you cannot have a look at your latent images, perhaps using a magnifier to examine focusing accuracy or graphs called histograms to check exposures. Nor can you delete the ones you do not like and use the emulsion again. Digitally, you can, and this is just the beginning.

Being able to delete – or 'chimp' as the process is commonly known – incorrect exposures, poor compositions or simply boring pictures frees up space for more shots.

Editing in-camera and ensuring you only keep good pictures maximises the storage capacity of your media card. That is a good thing but you should still at an early stage in your digital shooting supplement the supplied media with a large capacity card, say a 512MB.

Portable memory

It is reckoned photographers switching from film to digital take up to five times as many pictures. For heavy film users, this is a serious amount of pictures and they need managing.

On a day trip, a couple of storage cards will be enough until you get home when the cards can be downloaded and reformatted. You can see from the table opposite roughly how many shots you can get on various-sized cards in different modes.

Shoot lots of RAW, TIFs or high quality JPEGs away from base for a longer period and you need a storage solution to free up media cards, which is what I discuss here.

The ideal solution is a pocket photo album into which images can be downloaded, allowing memory cards to be reused. These units are battery-powered and work without a computer. Back home and the album is connected to the computer and it behaves just like another hard drive.

Pocket albums come in different types, sizes and levels of sophistication. Generally, they are relatively expensive.

Above: Burning CD-R disks without a computer is simple with a standalone CD recorder like this.

Right: Travel around with a high resolution digital camera and it is worth investing in an electronic photo album.

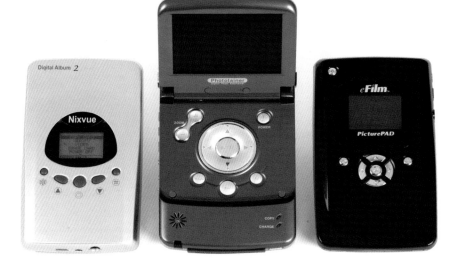

How many pictures on a card?

With a six megapixel camera, this is approximately how many pictures you can get onto storage media of various capacities.

	32Mb	128Mb	512Mb
RAW	5	20	80
TIF	3	12	50
Fine JPEG	13	50	210
Normal JPEG	23	96	390
Basic JPEG	40	155	640

A pocket album means downloading and clearing memory cards can be done on location. This model has a large integral screen for checking out pictures and can also play MPEG music files.

Some units are first and foremost MP3 music players, which accept optional, add-on accessories to read camera media cards. For imaging use, they may be relatively primitive.

There are more and more models designed for photographic use and many have a small viewing screen, a slide show function and a magnifier so images can be closely examined. You may also get a feature which displays image details such as exposure settings.

If you intend shooting RAW quality it is worth checking that the album can preview such files because not all can.

With a storage capacity to 20GB, 30GB or 40GB, an electronic photo album has enough capacity for the needs of most photographers.

The CD option

Another short-term option is a CD writer with the facility to accept media cards. Most CD writers need to be used in conjunction with a computer, but buy a standalone, battery-operated unit and you have complete freedom. Recordable CDs (CD-Rs) are a reliable, durable medium, certainly good enough for short-term storage, and with capacity of 650Mb, 700Mb or even 800Mb, a pack of discs is enough for most trips. And if you run out, CD-Rs are easy enough to buy.

Once on CD, the images can be viewed and downloaded onto a computer in the normal way. With important pictures, one thing I would suggest is that two CDs are made.

Nowadays, you can go to a processing lab to get images down-loaded onto CD, although this might not be convenient if you are travelling around. More and more processing laboratories offer this service and usually supply an index print for easy reference.

The thing to ensure here is that the file is not altered, down-sized or played around, with in any way. You want the pictures in the format that you picked at the time of taking them.

Yet another option, though slightly more cumbersome, is travelling around with a laptop computer and a card reader. Of the options discussed here, this is the least practical and the most expensive unless you already own one. However, modern laptops are portable, powerful and highly featured, making them great for photographers on the move. Buy a universal charger and you can power up via the car's cigarette lighter or the airplane seat power socket. With a laptop you can also manipulate images as you travel around, while its on-board CD or DVD writer allows images to be backed up.

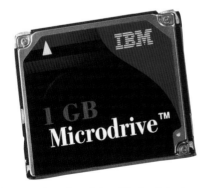

Large capacity media cards have fallen hugely in price so they are much more appealing. A card of 1GB capacity can hold up to 150 RAW files from a six megapixel camera – that's equivalent to four rolls of 36 exposure film.

2 The digital darkroom

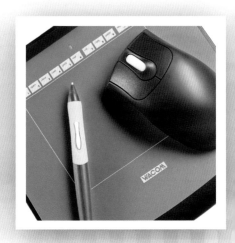

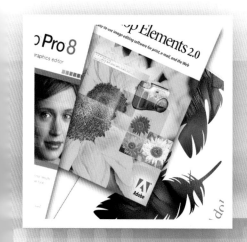

The digital darkroom

Taking the shot is the beginning of a long journey involving different pieces of kit and processes, some of which are simple, others much more complex. First, though, you need all the gear for a digital 'darkroom' set up.

The advent of the digital darkroom has opened up many creative avenues and, whether you shoot film or digital, the photographer has more control than ever before over the final results.

The term 'darkroom', of course, is obviously

a contradiction because digital does not need a blacked-out room. So, whether you prefer darkroom, the work station, imaging centre or simply the computer, it all amounts to the same thing: a set-up where you can import, store, edit and output your photographs.

The extent and sophistication of your set-up depends on how much of digital imaging's potential you want to exploit and your approach to photography. If want to dabble, a computer and a basic image editing software package is fine. If, like me, you want to shoot

film and digital, and make A3 prints, clearly the commitment in time, hardware, space and money is much greater. Over the next couple of pages, I outline the kit you need for a system that would suit keen photographers.

The computer

The computer is the heart of your imaging system and it is to this that peripherals such as the printer, scanner, card reader and extra hard drives are connected.

The computer market is incredibly fast-moving and obsolescence is a way of life. It is not worth kidding yourself that a new computer is an investment. Think of it as a tool, a means to an end, and accept that it will be out of date very soon after you buy it.

The good news is that the fast-moving market means there is great value to be had from a huge choice of products that is constantly advancing.

It is worth budgeting as much as possible and getting a fast machine with plenty of RAM and hard disk space.

High resolution images mean large files and a fast processor means software tasks are performed more quickly. Processors are quoted with a clock speed, expressed in megahertz (MHz) or, more commonly now, gigahertz (GHz). The fastest processors currently available are in the order of 2.6Ghz, and naturally the faster the machine the greater the cost.

Processor speed has a direct influence on performance but you also need to consider the amount of RAM (random access memory). This is the amount of memory a computer has instantly available to run a program, so the more you have the better.

Softwares are usually quoted with

Apple or Windows? The big debate

The computer world is dominated by the Windows operating system and computers now come with the XP operating system. The Windows system offers the greatest choice of hardware and software, the widest support and the best value for money.

Personally, I am an Apple fan, which I find more intuitive to use and the latest OSX operating system is very stable. Apple Macs are very popular in the imaging and graphic design industries and the latest machines are powerful, innovative, look fantastic and offer good value for money. Ultimately, however, it all comes down to a matter of choice.

I have a Sony Vaio laptop running Windows XP Home as well as my Apple and that means I have both options covered.

minumum RAM needs. As a guide, you want at least three times more RAM than the image file you are working on. With high resolution imaging files of 100MB or more, you can see that the usual supplied minimum of 256MB RAM is barely enough.

Buying extra RAM at the same time as purchasing the computer is obviously sensible, especially if, like me, the process of installing extra RAM sounds daunting. Actually, the process is simple and I have managed to upgrade my computer to 1GB of RAM without experiencing any problems.

Storing images

Hard disk capacity is important. Modern hard drives have capacities of 30, 40 or 60GB or more and that is a lot of memory. Well, it sounds like a great deal until you start imaging in earnest and you will be amazed at how quickly the hard drive fills up.

Adding software and making photographs will soon eat up memory. A single high resolution scan from a 35mm slide from my film scanner gives a file in the 100MB region and twice that if I opt for the 16-bit option. With the latter, even with LZW compression, a

TIF file takes up a massive 100MB worth of hard disk memory.

Housekeeping of your hard drive is important for other reasons than just the risk of running out of space. Accessing files from a heavily laden hard drive is slower, finding files is a pain and there is the risk of 'losing' images. Most importantly, if you have a problem with the hard drive you risk losing a great deal of work.

All this explains why downloading and archiving files off the hard drive is an important discipline to get used to. I cover archiving onto CD, DVD or separate hard drive on page 48.

If your hard drive is full of images at the moment, I urge you to sort them out before adding any more. Dump the rubbish and archive the finished good stuff right now.

The latest computers come with a CD recorder/rewriter as standard and this is a valuable aid to keeping the hard drive free of clutter as well as a cheap and reliable method of archiving.

If your computer has a read-only CD drive, it is time to invest in a recordable version. They are good value and work with CD-R (Recordable) and CD-RW disks. CD-R disks are cheap, record-once only CDs that are available with capacities of 650Mb, 700Mb and 800MB – not all are fully compatible with every drive so check this. CD-RW disks are rewritable CDs and can be used over and over again, although these are more expensive than CD-R disks.

The latest option to consider is a recordable DVD drive. In my experience, the process of recording DVDs is more fickle than CDs and there are various formats right now, but the extra capacity of 4.7GB in the same size disk cannot be dismissed lightly.

I make no apology for labouring the importance of an organised archive. I have lost too many vital images by being too naive and trusting or have simply wasted too much time looking for urgently required shots. Save heartache and angst later by being paranoid now.

I have such a commitment for keeping my images in some semblance of order that I use a portfolio or a 'digital asset management' software and I recommend you do the same. Furthermore, a good portfolio package will enable you to catalogue images with key words so finding them in the future should be simpler.

A room with a view

Buy a computer outfit and it will usually come supplied with a monitor. Nothing wrong with that but as you get deeper into imaging you may want to consider one that offers a larger 17in or 19in screen, which gives an image that is easier to work on and saves you spending too much time navigating around.

Conventional screens are CRT (cathode ray tube) type, just like a domestic TV. They are high resolution and excellent quality but they have a relatively large footprint so if you have a small desk area this is an issue. Clearly, the possibility of a bigger monitor is not even an option if there is no room.

Space-saving, flat LCD screens are gaining popularity. Early LCD monitors lacked sparkle and you had to sit square on to view the screen properly. That is not the case now and image quality is excellent with high resolution and rich colours. Their big

Graphics tablets

A computer mouse is easy to use and perfect for most applications. For imaging, however, it is well worth investing in a graphics tablet. This is a touch-sensitive pad that mimics the computer desktop. To navigate around, you just use a special pen-like device. For general use, I still prefer a mouse but I love the tablet for making selections, especially around areas of fine detail. A small A6 graphic tablet costs £70 so making life easier does not cost the earth.

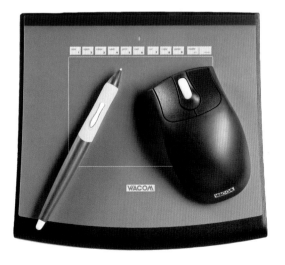

A graphics tablet is ideal for making complex image selections, like cutting around hair.

advantage, compared with CRT screens, is how compact they are, making them more suitable for the home.

Your working environment at home is something to be considered seriously. Purpose-designed furniture for work stations are definitely worth the money, especially if your set-up goes beyond a computer and monitor. Obviously, you need to think not only of what you own now, but how much more gear you are planning to add in the future.

An office quality chair with adjustable height and lumbar support is advised, particularly if you want to undertake lengthy imaging sessions without fatigue.

Monitor placement is very important if you are to avoid eyestrain, neckache and bad posture. As a guide, locate the screen at head height, where it is not picking up reflections and at a suitable distance. Sit down at your normal position and stretch out an arm and, ideally, the screen should be just within touching distance. Use books or a monitor stand available from office equipment stores to achieve the correct viewing height.

There are other health and safety considerations you should be aware of. Take frequent screen breaks and make sure your wrists are well-supported (supports are available) so that you do not lay yourself open to the risk of repetitive strain injury (RSI). RSI is something that creeps up on you and I have found that using a rollerball-style mouse and a graphics tablet help.

Digital imaging is addictive and once you start playing with images, time can fly by, which is why consideration of your station and how you work with it is important.

Interface options

There is no point buying a computer with not enough sockets to plug in your many devices. The two main 'interfaces' are USB (Universal Serial Bus) and FireWire (IEEE1394).

USB 2.0 is now standard on new computers and this interface offers a data transfer rate of 480Mb/sec (megabits per second), which is 40 times faster than the older USB1.1. Externally, both USB sockets are identical. The USB interface is also the one used for plugging in accessories such as the computer mouse or storage card reader and it is simple to use and very stable.

FireWire has a transfer rate of 400Mb/sec, although the newest variant gives twice that. FireWire (also known as I-Link) is popular for downloading video footage from camcorders.

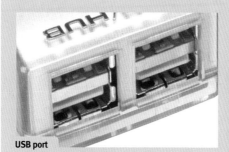

USB port

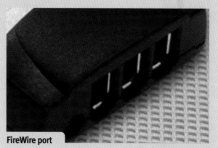

FireWire port

Card readers

Digital cameras come supplied with leads and software to download pictures direct to the computer. Some models have 'docks' that enable convenient transfer of images while recharging the camera at the same time. I prefer to use a card reader. This gadget plugs into the computer and

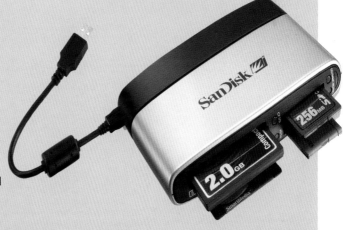

you just slip in the media card, which shows up on the computer as another hard drive. With Mac OSX and Windows operating systems there is usually no software needed and card detection is automatic. Many card readers also have the advantage of being multi-format so that different cards can be accepted, so they are very convenient.

Image editing software

Buying the computer is just the first step. You cannot do anything without software and there is a huge selection of image editing products to choose from.

Software is big business and thousands of packages are available. You only have to visit the computer store to see that, while on the Internet you will see freeware, shareware and plug-ins aplenty. But what do you truly need, what would be nice to have and what is a waste of time? Determining what is useful and what is not is incredibly difficult without knowing what you want to achieve.

Some software is full of gimmicks while other packages are genuinely useful, but software is always sold on the promise that it will do something that you want. Of course, what you do not know (from the box at least) is how that software works and if it is easy to use or not. Reviews in the specialist computer and imaging press obviously help but there remains no substitute for experience.

To keep things simple, I have put the software featured over next four pages into two broad categories. I start here with image editing software and over the page is a selection of software to enhance enjoyment of your images. There is cross-over between the two sections because some packages are so versatile and there are many more products out there that I have not covered, so take my selections only as suggestions.

A software choice

The software that straddles the imaging world like a latter-day Colossous is Adobe Photoshop, now in its CS (Creative Suite) or version 8.0 incarnation.

In the imaging industry, Photoshop is a software that can be called a 'standard' and it is used not only by photographers but also by publishers and reprographic companies. In colleges and universities, it is also the software most taught on media and imaging courses.

With so many imaging professionals using Photoshop, it will not surprise you that it is also expensive, which makes it difficult for amateurs to justify. That said, this is the software to save up for because it is very powerful and there is little that it cannot do. It is available for Windows and Mac platforms.

Photoshop CS has many refinements over the 7.0 version that it replaced. The extra features that will appeal to photographers are the ability to deal with RAW files, 16-bit image editing, a powerful File Browser and a Shadow/Highlight adjustment.

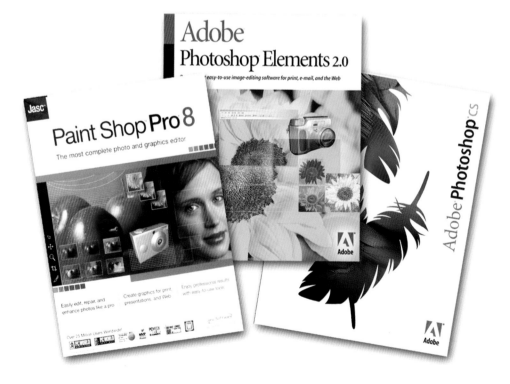

Adobe has a cut-down version of Photoshop, called Photoshop Elements 2.0. This is much more affordable and often comes 'bundled' free with top-end digital cameras, scanners and printers.

Elements is a powerful package that is perfect for photographers who want to make the main improvements to the image – Levels for exposure control, a Crop tool to enhance compositions and Unsharp mask for optimizing sharpness. But it is also tremendously capable on the creative side too. Layers and Selection Tools, for example, should keep most users happy.

A powerful package that is Windows only but offers tremendous versatility at a fraction of the cost of Photoshop is Jasc Paint Shop Pro, version 8.0. Personally, I do not find it user-friendly, but that is a subjective point and once past this Paint Shop Pro has enormous potential.

RAW conversions

I have included RAW conversion programs on these pages because they are an important form of image-editing software.

A RAW file from a digital camera is everything captured off the sensor with no processing or any in-camera modification. Because a RAW file is a 'digital negative', the conversion software used has a fundamental impact on the image's characteristics.

Cameras capable of RAW shooting are supplied with conversion software but it might not be the best one to use. In my experience, a compatible third party software can be more user-friendly, allowing faster processing, more logical interfaces and greater control over exposure, tonality and colour balance.

What is a plug-in?

Cutout plug-in filter

A whole industry has grown up around Photoshop's support for third-party plug-ins. These give the program extra creativity or functionality and Photoshop filters are typical.

Plug-ins are downloadable from the Internet usually at a small cost as well as freely given away with imaging books and magazines. Off the Internet there is usually the option of a free limited trial of the plug-in before committing money and clearly that makes sense because some effects you might tire of really quickly.

Adobe Photoshop CS has a RAW converter built in and the 7.0 version will accept a RAW plug-in, but there are plenty more RAW processing options. BreezeBrowser, dcRAW-X and Phase 1 Capture One Pro are three well known ones. For more information about these softwares and for downloadable, limited use trial versions, visit the websites.

BreezeBrowser For Windows only
www.breezebrowser.com
dcRAW-X For Mac OSX only
www.frostyplace.com/dcraw/
Phase 1 Capture One Pro For Mac and Windows and various editions are available.
www.lapfoto.com/phaseone.html

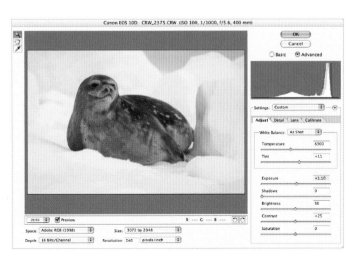

Adobe Photoshop CS has a very capable and versatile RAW converter with plenty of user control. It is fast too. For more details visit www.adobe.com

Practical software

If you want to make a panorama, produce a brilliant audio-visual picture show, put borders on shots or just manage your images, there is a program available.

Enjoying and sharing your pictures has never been more fun or creative and there is little that cannot be done on computer.

Most softwares are easy to use and multi-functional so there is plenty of overlap in my broad categories. For example, you might get picture management, CD burning, basic web design and picture presentation templates all in one convenient package.

Which softwares you will find useful obviously depends on what you want to do with your pictures. I have programs for managing pictures and making presentation CDs of my work.

Digital asset management

Side-step the jargon and think filing system. This is software for cataloguing and managing images and within this group, I include photo albums like Apple iPhoto and JASC Photo Album as well as more advanced softwares like Extensis Portfolio.

In my view, a good software that can help you organise and check your shots of different formats quickly and efficiently is absolutely vital. Some imaging softwares like Photoshop CS do have a file browser but a dedicated database software can be more powerful and user-friendly.

CD and DVD software

I have grouped both of these softwares together, basically because many programs can now deal with both media types, providing the appropriate drive is available. The latest computers have CD-R/RW drives as standard and are able to playback DVDs but recordable DVD drives are increasingly popular.

CD is a convenient, reliable and very cheap method of moving files around and for storage. The 650MB and 700MB CDs are the most popular; 800MB CDs are available, although older drives or software might be incompatible with these newer disks.

Showing your pictures on screen via a computer or a home DVD player is a wonderful way to share your images and it is possible to do this with even with a CD-R/RW recorder and disks. All you need is suitable

A good cataloguing software lets you browse and keep track of your images but, like with any filing system, you have to do some work too.

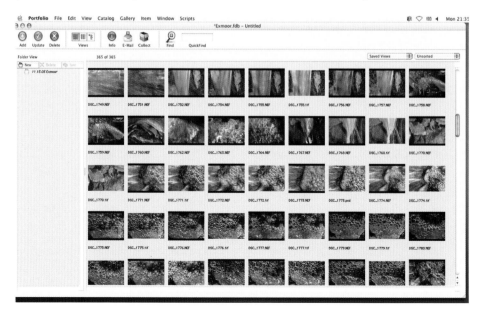

software to burn disks as Video CDs (VCD). VCDs use MPEG compression so you can add a stereo soundtrack and they can be played on most DVD players and computers with DVD-ROM or CD-ROM drives with the right software. The image quality obtainable with VCD is comparable to VHS video tape.

The principle of making DVDs of your photographic prowess sounds great but expect a few problems. I have had DVDs crashing during recording and if I do manage a finalised DVD they do not playback in older players. Deal with the problems, however, and there is great potential with this medium and the price of DVD recordable disks has dropped significantly.

Stitching software

Panorama pictures of stunning scenes can look spectacular and they are easy to produce assuming, of course, that you did a decent job of taking the pictures in the first place. Some digital compact cameras have an assist facility for accurate pictures.

Softwares like Photoshop CS and Elements have a PhotoMerge feature to automatically

...and some more ideas

Make a slide show

Many digital album/CD softwares let you make a professional quality audio-visual presentations, with neat fades and a digital soundtrack. A software to try is PicturesToExe, featured on page 144.

For prints with borders

Digital lets you present images in any way you choose. Simple borders are usually the most effective and making your own is fairly simple. I show you some ideas using Adobe Photoshop on page 140. However, if you want themed borders to allow such things as birthday cards to be made, software is available. Some templates are dreadfully cheesy but the tasteful stuff is great.

Website design

There is a huge range of software for web design, from the very simple to highly sophisticated and expensive packages like Macromedia Dreamweaver. The basic packages feature pre-designed templates and you just add words and pictures. My web site was designed by a friend in Dreamweaver and I will not pretend to know what I am doing in softwares like that. I leave it to the experts!

Looking after your system

Look after your system by using a virus protection software and pass downloads and new documents through it before opening. It pays to be safe.

stitch several images together, but you can also do it manually.

If you want to take panoramas seriously REALVIZ Stitcher is probably the best software around but its high price reflects this. There is a plethora of much cheaper stitching softwares downloadable off the Internet so I suggest you search around.

Making pictures bigger

Image editing software lets you resize an image for bigger prints and does this by a resampling process known as interpolation.

Basically, this is the software guessing at missing pixels, ie resampling, to produce the bigger image at the desired resolution. Photoshop and Paint Shop Pro have good interpolation facilities but you could

try something like Genuine Fractals or Extensis SmartScale. Both work to good effect and offer more controllability than using image-editing programs on their own.

Scanners

The scanner is a vital accessory in the digital imaging chain. Two types are available, the flatbed and the film scanner, and it is worth having both in the digital darkroom.

My digital darkroom has a flatbed and a film scanner because they have different roles.

A film scanner has only one purpose and that is to digitise my film originals for archiving and enhancing in the computer. I have a four-drawer filing cabinet full of 35mm transparencies and thousands upon thousands of black & white negatives accumulated from over 30 years of photography. This archive is added to regularly, which is why I invested in a high quality film scanner.

The flatbed is a much more versatile input device and I scan prints, artwork, typed pages and three-dimensional objects such as sea shells, flowers and leaves. In fact, anything that can be rested on the plate can be scanned.

More about film scanners

Flatbed scanners are high resolution, have good optics and can scan film originals, so you might be wondering why you need a separate film scanner. It is all to do with resolution, quality and output size.

On resolution, there are many flatbeds of 2400ppi and a few models offering 3200ppi and 4800ppi. These are the true optical resolution figures, not enhanced or interpolated figures which are often bandied about by manufacturers.

As you can see from the table over the page, a 2400ppi model gives a print of just under A4-size at 300ppi from a 35mm image. Obviously a 3200ppi or higher scanner would be a better buy in the long term and would enable bigger prints without any software interpolation.

But there is more to it than the bare bones of resolution. Take a flatbed and film scanner of similar resolutions and scan a 35mm original and you will see differences. I have compared scans of the same size and resolution from both scanner types and the film scanner results are definitely superior with more detail, greater accuracy, better sharpness and less colour fringing.

This is because film scanners, generally, have better, more critical optical systems. Many models also have software to remove dust and scratches, although to be fair, flatbeds are coming out with this too.

Tips for successful scanning

The scanner is an input device, so it follows that you should do all you can to get the maximum amount of information off the image in the first place. Here are a few tips.

Decide on the purpose

If you are only making a small print, there is no point scanning at the highest resolution. A big scan takes longer and eats up more space. Only scan at the highest resolution if you are making big prints or archiving.

Clean the image

Use an air duster or blower brush to get rid of dust. Tidying up scans is easy in software but a few seconds spent here saves time later. If your scanner has a cleaning software such as ICE, use it. By the way, ICE does not work with black & white negatives.

Bit depth

Most scanners scan at 8-bits per channel (multiply by three for the three colours equals 24-bit) but you might have the option of 12- or 16-bit. For the very highest quality use one of the higher settings.

Do a preview first

Use the preview facility and check the image before going for the full scan.

Make corrections

A preview, even a low resolution image, will highlight any major short-comings and most scanners will let you modify crop, exposure, image contrast and colour balance. Make any necessary adjustments and do another preview scan before making the final scan.

Flatbed v film scanners

There is the case for having both types of scanner in a digital imaging set-up. This is particularly true if you have an archive of 35mm film originals that you want to digitise. A dedicated film scanner will make the most of your images. However, if you are a medium- or large-format film user, film scanners are very expensive so you may prefer to stick with one of the latest flatbeds which offers very high resolution.

Full image

Flatbed scanner Epson 3200

Flatbed scanners usually have a basic scanning mode but much more user-control is possible in the advanced setting, so use this.

Enlarged area

Film scanner Minolta 5400

Interfaces vary but more sophisticated models offer plenty of possibilities regarding resolution and image correction settings.

Enlarged area

Film scanners of varying resolutions and price levels are available. A typical budget model will have a resolution of 2900ppi but top-end models of 4000ppi, 4800ppi and 5400ppi are available.

I use a Minolta Dimage Scan Elite 5400 which is a 5400ppi resolution model. For archiving 5400ppi is the resolution I use, which results in files of 100MB after cropping and even saving them in a compressed TIF form means 50MB files.

These are seriously big files and take a little while to open even on a reasonably fast computer, and of course archiving them is memory-sapping. On the plus side, I can make large prints without interpolation.

Flatbed versatility

Flatbeds can scan film too, although as previously explained they are not perfect for 35mm originals. However, with medium- and large-format film, a top-end flatbed scanner is a perfectly practical option, especially as dedicated medium-format film scanners are so expensive.

Image cleaning software

Image cleaning software like Applied Science Fiction's ICE (Image Correction and Enhancement) found on Epson, Nikon and Minolta film scanners, can save hours of work with the Clone Tool. It cleverly detects and automatically corrects any image flaws, such as dust and scratches, and does so without compromising image quality, as you can see below.

Full image

Scan with ICE turned off

Scan with ICE turned on

Like most things in life, you get what you pay for but as far as flatbeds are concerned the great news is that a decent 1200ppi model will not cost too much. You might have even got one 'bundled' free when you bought the computer.

If you want to scan film, go for a 2400ppi or 3200ppi model at least.

The vast majority of flatbeds can deal with material up to A4 size (21x29.7cm). Larger prints can be dealt with by making several scans of different parts of the image and then merging them in Photoshop. I did this with great effect with some big old mono prints that I wanted to archive. It took time and some fiddling around but it did work. A3 scanners are available but these are expensive and used mostly in the reprographic industry.

A flatbed works on a similar principle to a photocopier. The material to be scanned is placed on the glass plate scanning surface, the lid closed and when you click the 'okay' button a chassis with a bright light source and lens scans the subject.

The manufacturers have made the typical flatbed easy to use. If you want to scan a picture to e-mail, or scan typewritten sheets, or get an image ready for your website, all you have to do is push the appropriate button. It is the versatility of a flatbed that makes it worth having and it can even be used as a 'camera'. Placing 3-D objects and scanning them gives images that can be played with later. See page 146 for more on this.

The software also lets you pick a simple scan mode or, if you want to tinker and modify, there is the option of an advanced setting. It is up to you.

What to look for in a scanner?

Resolution

A scanner's optical resolution is the maximum number of pixels per inch (ppi) it can record. Some scanners quote an enhanced resolution figure, but this is not a true measure of the scanner's ability.

Flatbed scanners are usually quoted with two resolution figures, ie 1200x2400 ppi. It is the first number that is important – this is the actual number of the sensors in the scanner head. The second number is how many steps or rows the scanner can register as the head travels down the subject.

Colour depth

Most scanners are 24-bit but increasingly 36- and 48-bit scanners are available. These are figures for all three colour channels (red, green and blue) so 24-bit means 8-bits per channel, 36-bit is 12-bits per channel and 48-bit is 16-bit. At 8-bits per channel you get 256 shades of grey, which is 16.7 million colours (256x256x256). With 12-bit you get 4096 shades of grey and 68.7 billion colours while at 16-bit you get 65,536 greys which delivers over 218 trillion colours.

On the downside, scanning at 12- or 16-bit is slower, gives bigger files and few editing packages are fully 16-bit compatible.

Optical density

Also known as dynamic range, this is the scanner's ability to 'see' tones. The tonal range is expressed on a scale of 0.0 (pure white) to 4.0 (black). Obviously, you want a scanner that can distinguish as much of this range as possible. A top-end model will have a dynamic range of 3.8 or more.

Scan and print size

This table shows the biggest print size you can get without any interpolation in software from a 35mm film original using scanners of different optical resolutions. The figures have been calculated assuming the 35mm image is the theoretical maximum of 24x36mm and the file size is an uncompressed TIF.

Scanner resolution	File size	Print size at 200ppi resolution	Print size at 300ppi resolution
600	1.38MB	7.2 x 10.8cm/2.8 x 4.2in	4.8 x 7.2cm/1.9 x 2.8in
1200	5.5MB	14.4 x 21.6cm/5.6 x 8.5in	9.6 x 14.4cm/3.8 x 5.6in
2400	22MB	28.8 x 43.2cm/11.3 x 17in	19.2 x 28.8cm/7.5 x 11.3in
3200	39.2MB	38.4 x 57.6cm/15.1 x 22.6in	25.6 x 38.4cm/10 x 15.1in
4800	88MB	57.6 x 86.4cm/22.6 x 34.6in	38.4 x 57.6cm/15.1 x 22.6in
5400	111MB	64.8 x 97.2cm/25.5 x 38.2in	43.2 x 64,8cm/17 x 25.5in

Home printing

Making exhibition quality prints in the comfort of your own home has never been easier and truly excellent image quality is possible at remarkably low cost.

Inkjet printing technology has been around for years but it is only relatively recently that the standard of prints has reached what can be genuinely called photographic quality.

I got my first inkjet printer in the late 1990s. It was a four colour ink model and while it had word 'photo' in its name the prints it made, even at the highest quality settings, were harsh and had a gritty look that compared very poorly against 'real' chemically made photographic prints.

Now, photo quality prints are possible from inexpensive printers and we are lucky enough to have a huge selection of inks and papers to choose from, so photographers can produce very individual looking results.

I have concentrated on inkjet printers rather than laser or dye-sublimation printers because they are so convenient, inexpensive and suit the home environment.

Laser printers are used in offices the world over but the ones designed for making photographic printing are used by processing labs.

Dye-sublimation (or thermal dye transfer) printers are standalone devices so no

computer is needed and prints can be produced direct from the storage card. Also on the plus side is that they give excellent long-lasting, photo quality prints. But there are only a few models available and they are expensive to run. There are models designed for 10x8in and A4-size prints while cheaper ones are limited to outputting 6x4in prints.

Inkjet technology

Inkjet printers use a number of different colour inks to produce the image. Typically, a modern printer will have cartridges loaded with cyan, magenta, yellow and black inks. Some models have extra colours such as a light cyan and magenta inks for greater colour accuracy.

As the paper is fed through the printer

head, hundreds of tiny nozzles open and squirt minute droplets of ink on the paper. As technology has marched forward so the size of these tiny ink droplets has got smaller and smaller. A typical model can give droplets of two to four picolitres – a picolitre is a million millionth of a litre – which gives a dot of around 30 or so microns. A single ink droplet of this size is just visible to the eye.

Much has been made about resolution and photo quality models quote anything from 1440 (dpi) dots per inch to 5760dpi. It is worth noting that with six inks, a quoted resolution of 1440dpi is in fact only 280dpi per colour.

In my tests, I found there was actually precious little to gain from printing at any resolution higher than 1440dpi with the

matt textured papers that I prefer. It is only with the highest glossy finishes that any differences are noticeable and the tonal gradation is smoother. The cost of this is longer printing time and greater ink consumption.

Controlling costs

Inkjet printing is easy, convenient and great quality but there are downsides, notably print longevity and the cost of media.

Inkjet print life is a serious consideration. With traditional prints lasting 70 years and more, even with moderate exposure to light, inkjet technology was always going to find it tough to compete.

From my own, admittedly not very scientific tests, I have had unframed prints on the wall of my quite dim living room fade beyond acceptable limits within months. In brighter situations, prints have faded in weeks.

However, ink and paper technology is advancing all the time and long-life prints with the right products are possible.

The other downside about inkjet printers is the cost of keeping them fed with ink. Replacement inksets, especially from the printer manufacturers are not cheap, which is the reason for the explosion in the market for third-party inks, as well as refillable cartridges and continuous ink systems.

While it is true that inksets are not cheap, the cost per successful print compared with chemical processing is actually very good. When I used to chemically print from slides, out of a 20 sheet pack of paper I would manage a handful of perfect prints.

By comparison, with inkjet printing the hit rate is so much higher and the process itself is painless and fun.

Printing tips

■ Handle papers by the edges and keep fingers off the printing surface
■ Read the instructions for advice on the optimum printer/ink setting

■ It is worth trying different paper settings for the best results
■ Let prints dry for at least 24 hours before serious handling

Continuous ink

My printing set-up comprises two six-ink, A3+ Epson 1290 printers. Both are fitted with PermaJet (www.permajet.com) continuous ink systems (CIS), one fed by colour ink and the other with mono inks. The initial investment of a CIS is considerable so it is only worth the cash if you are a prolific print maker. If this is the case, a CIS will, in time, save you money.

Early CIS outfits were clumsy, inelegant affairs but that is not the case now. Initial set-up is easy as is maintenance and as soon as you see the ink getting low, just top up the bottles. The intelligent chip that is a feature of printer cartridges is reset when the printer is turned off.

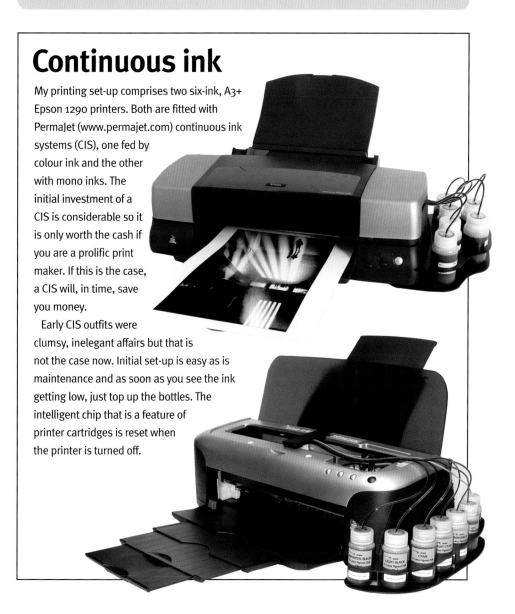

Inks & paper

Make prints and you use ink and paper media. And lots of it. Luckily for us, there is a huge range of options to choose from.

One of the joys of home inkjet printing is the incredible choice of paper types, weights and finishes. There are hundreds more options than you get with chemical printing. Not only does this mean almost every possible taste is accounted for but your images can have a very individual look and feel.

The newcomer to inkjet printing is more likely to feel overwhelmed by the huge number of options rather than feel reassured. The result of this could mean an unwillingness to stray from the materials recommended by the manufacturer of the printer which, surprise, surprise, are usually their own products. That would be a great shame and I encourage experimentation.

Which papers?

Deciding which paper to use is plainly a subjective matter and depends on individual taste as well as image content.

When I print my black & white images chemically, I invariably use glossy paper, for the extra depth and richer blacks, which I air-dry to give a lovely, smooth sheen finish.

In inkjet printing, however, I have gone matt and love the textured 'art' or 'watercolour' finishes, especially on a heavyweight base of around 260-300gsm. By the way, these textured papers are coated for inkjet use and I

do not mean the materials available from art shops and used by painters. Such materials can be put through an inkjet printer but the lack of coating will give poor tonality, smudged images and poor definition. That said, the effect with the right image can look good.

Matching the image to the material is clearly an important point to consider. Taking a traditional stance, textured or matt papers are perfect for portraits and pastoral landscapes while for building and action pictures a glossy or pearl finish paper would be better.

To be fair, there are no hard and fast rules and it is matter of personal taste. Just consider the subject and how the print will be viewed or presented.

With inkjet printing still relatively new, it is true that many materials do not 'feel' especially photographic but that will change as paper, bases, weights and finishes continue to be refined.

Finish is one aspect that needs considering, another is paper weight, which is usually quoted on the pack. Papers are quoted with a 'gsm' figure. This stands for grams per square metre, and the higher the figure the thicker the base and the heavier the paper.

It is worth having a variety of different weights to hand. The lighter papers (100-150gsm) are fine for index and proof printing while the heavier materials (250gsm upwards) are excellent for decor, portfolio and exhibition purposes.

Choosing your ink

Not long ago, there was no option but to use the manufacturer's ink. Now the scenario is very different and there is an ever-expanding number of third party ink cartridges for photo quality printers on the shelves.

The key reason for choosing different brands is cost. Make lots of large, high quality prints and inkjet printers are expensive to run, especially if you use the manufacturer's own replacement cartridges.

Generally, third-party inks are cheaper and with a little tweaking or a new profile any differences are minimal. It is worth trying different brands to see which you prefer.

If economy is top of the priority list, an option available for some printers is the continuous ink system (CIS). A CIS set-up comprises a cartridge insert complete with an intelligent chip connected by plastic tubes to bulk bottles of ink. In theory, so long as the ink bottles are loaded and the printer heads remain unclogged you can make print after print.

A CIS system is not an elegant solution but if you are a prolific print maker one must be considered. Given the initial outlay, if you only make a few prints a month, you will be better off with conventional replacement cartridges.

Economy and colour performance are key aspects of inks. Another, of course, is the can of worms known as longevity.

The printer, ink and paper makers have not helped themselves. Claims that prints will last umpteen years in an atmosphere-controlled, candlelit room are unrealistic. Different inks and papers, the printer and the display conditions all have an impact on longevity and with so many variables, you can appreciate why it is impossible to be definitive on print life.

I have had prints on display behind glass in the shade fade within months while others are in original condition. If print life is an issue, invest in printers, inks and papers designed for 'archival' use. Archival inks are pigment-based which are more water-resistant and lightfast compared with dye-based inks.

Personally, I prefer to rely on tried and trusted technology, so if I want prints to last I burn a CD and send it off to be printed by a lab on a long-lasting photographic paper like Fuji Crystal Archive or Kodak Endura.

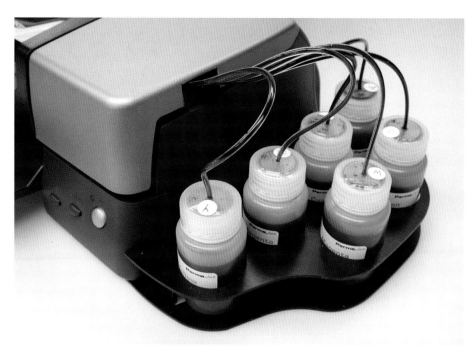

Make lots of prints and you will consume a great deal of ink. In this case, consider the option of a continuous ink system (CIS). The initial setting up cost is high but in the longer term a CIS system could prove a worthwhile investment.

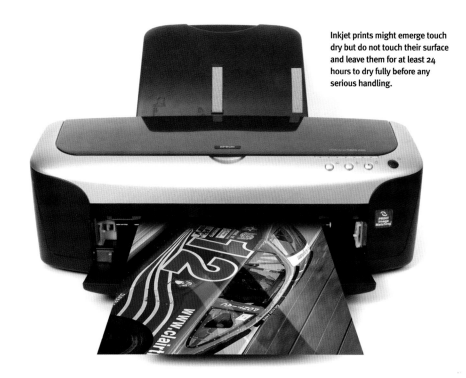

Inkjet prints might emerge touch dry but do not touch their surface and leave them for at least 24 hours to dry fully before any serious handling.

Store it

Nothing drives a photographer to despair more than losing their pictures. With digital there is that risk but with the latest technology there is no reason why you should ever lose a picture again.

As you produce more and more digital images, you will develop a workflow for your pictures and this topic is covered in detail on page 104.

Safe storage of your digital files is a crucial step in this process and is overlooked at your peril. With digital, if a hard drive crashes, a media card formatted in error or a CD scratched, retrieving the images might be impossible. In my experience, despite taking great care, such disasters do happen so it is important not to be complacent.

In fact, I am paranoid on the subject, having lost lots of files due to my incompetence, plain ignorance and, most commonly, technical failure. Learning in the school of hard knocks is painful but very effective, so take it from me you are better off skipping the pain in the first place and putting safety measures in place.

Archiving your pictures

The system you devise to archive pictures clearly depends on how prolific you are. The more you shoot, the more organised and disciplined you need to be in your procedures. Not only that, but short- and long-term storage demand different approaches.

I always take the view that if something can go wrong, it will and thus avoid having all my eggs in one basket. Consequently, as soon

as I have down-loaded my pictures from the storage card, I copy everything onto an external hard drive before doing anything else. Such drives are reasonably priced and with FireWire or USB 2.0 interfaces, moving large amounts of data around is fast. This means that if there is any problem with the computer you have the original files.

If you do not have an external hard drive, buy one. There is a wide choice available and they are not expensive considering the convenience and security they offer.

The alternative back-up is the humble CD. Most computers have a CD drive (if not, external writers are available at reasonable cost) which lets you record data onto CD-R or CD-RW media. CD-R disks are single burn or multi-session but once finalised the CD cannot be over written, unlike CD-RW disks which can be erased and used again and again. Such disks are more expensive than CD-R media but keeping picture files on CD-RW disks until you are ready to archive the final images is worth considering.

I know there are doubts about whether CD as a format will be around in 10, 20, 50 years hence and thus accessing an archive might not be possible. But the format seems so prevalent now that I cannot imagine this happening suddenly or without any

backwards-compatibility in the new systems. Recordable CDs have a capacity of 650/700/800MB, though do check that your drive can deal with the larger capacity CDs. CD-R disks themselves are cheap, especially when bought in bulk packs.

For short- to mid-term back-up or sending out to clients, I use budget-priced CD-Rs bought in bulk. I have found this a reliable storage method and because CD-Rs are so cheap I often burn two disks so I have a back-up of the back-up.

However, for archiving of 'precious' images I take a slightly different route. Clearly, not every picture deserves the full archive treatment and that is a decision for you to make. To me 'precious' means original RAWs (consider them as digital negatives), family pictures and high resolution scans of my best film originals.

CD-R media come with different base colours – green, blue, silver and gold – according to the recording dye base used and this has a fundamental impact on the longevity of the data.

Gold (phtalocyanine dye) CD-Rs are claimed to have the best long-term storage properties but there is nothing absolutely certain and a great many variables. For long-term storage I go for more expensive, gold-dye CD-Rs which claim reasonable longevity. I collect enough images to fill a CD at one burning session and burn two disks, verify them, make sure the images are there afterwards and then put them back in their jewel case. One set of CDs sits in my house, the other is stored off-site.

Recordable DVD is another storage media to consider although I must admit I am not totally convinced. The theory is great: each DVD has a

capacity of 4.7GB, although in practice it is more like 4.4GB but this is still several times more than CD. The discs are more expensive but it is true that prices have come down a great deal.

The lack of a true 'industry standard' is irritating. The choice is between the '+' or '-' formats. DVD+R is the more common than the DVD-R right now and there is the RW (Rewritable) option for both formats too. Dual-format DVD writers are arriving that are R and RW compatible although I have found even with the right discs that I get too many failures. That said, once successfully burnt I have had no problems reading files.

My archiving procedure still centres on using CD-R as already explained but I also back-up onto DVD as well as my external 200GB hard drive. Once that drive is full I will buy another, which sounds extravagant but it works out at less than £1 per GB.

External, high capacity hard drives are attractively priced and offer a convenient method of long-term storage. The latest FireWire and USB 2.0 interfaces also mean that managing and transferring images is a fast process.

This rather involved process is time-consuming and expensive but if one media should fail I still have two chances. Until I lost a bunch of valuable pictures due to technical failure, I would have said such a palaver was over the top, but now I appreciate the peace of mind that this a little extra effort brings.

Successful CD burning

Archiving your valuable work is a serious business and here are some points to consider when burning your invaluable pictures to CD and DVD.

■ For archiving purposes, buy high quality disks that promise good longevity
■ Make sure the media suits the writer
■ Do not touch the recording surface and handle discs carefully by the edges only

■ Burn at less than top speed
■ Keep the CD free of dust
■ Do not use the computer during burning
■ Organise your files to burn discs at one session rather than in multiple sessions
■ Verify the CD. Dump disks that fail verification
■ Check that files open properly via the image-editing software or can be transferred to the hard drive
■ If you are making archive

disks, put finished disks straight into storage using the supplied jewel case
■ Make two copies, one for off-site storage
■ If you do use an archive disc, download the file to the hard drive, and return the disc to its jewel case immediately
■ Write the disc's contents on the supplied index sleeve. Only use water-based ink pens on the disc itself and never use sticky labels

■ For easy reference, make an index print of the contents
■ Store discs in a cool, dark, dry, atmosphere

3 Taking great digital pictures

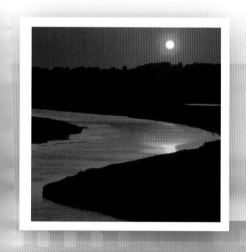

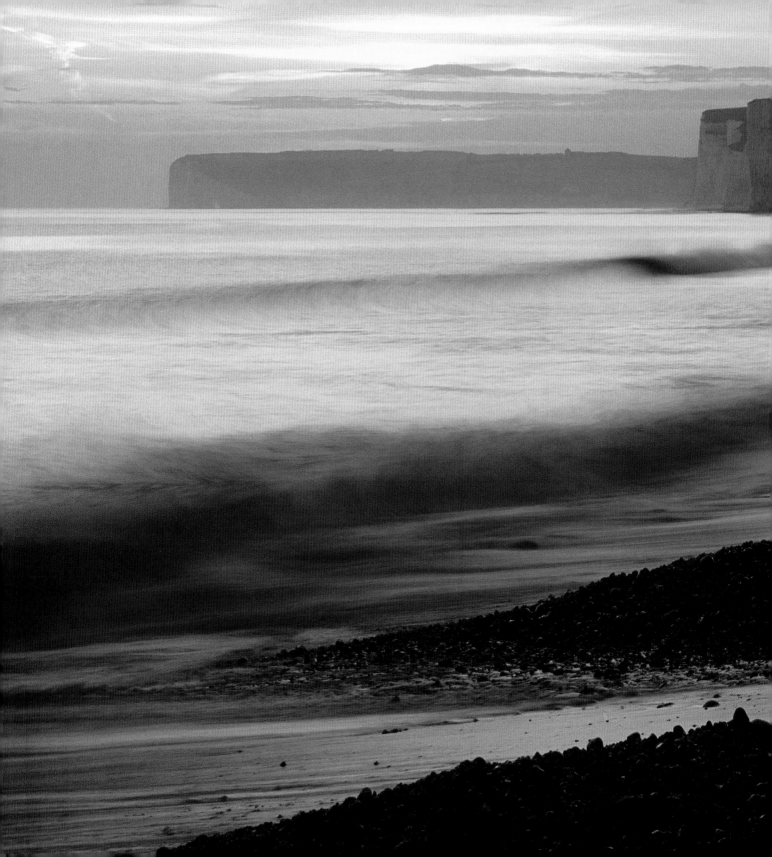

Taking great digital pictures

The creative and visual skills needed to take a great photograph, whether it is on film or with digital, are the same. And you still have to be there.

A good photograph is a good photograph regardless of which medium it is taken on. That might sound blindingly obvious to you but I meet plenty of people who believe that there are creative differences between capturing a great film image and a stunning digital one. It is my belief, and remember I am talking about capturing the decisive moment here, that there are none. Put another way, for all the convenience of digital, you still need a scene worth picturing, great composition, spot-on timing and beautiful lighting.

I labour this point only because I hear of photographers who will grab a picture with the intention of correcting it in the computer. Taking a picture to use in a grander, multi-image composition is one thing, but taking a photograph with the express intention of correcting it in computer does not sit comfortably with me. That is my personal view and I will continue to strive to get the picture as perfect as possible in-camera and encourage anyone wanting to enhance their skills to do the same.

Aesthetics aside, there are, of course, important differences in the technical side of the picture-taking process.

In this chapter, I cover the most popular subjects and how you can make more of them, whether you are using film or digital or both. Plus, at the end of each section there is an aspect of digital technique explained.

Ultimately, if the final picture is worth looking at, it does not matter if it is on film or on digital and great pictures usually involves effort such as getting up early, looking for the best viewpoint and waiting for the right light.

Shoot weddings

A couple's big day is an excellent opportunity for wonderful pictures of family and friends relaxing and having a great time. It should be fun for you too and a challenge.

Recording a couple's big day is not too be taken lightly so I will start by saying that I am not here to encourage amateurs to take on that responsibility. If the idea of making a living from this challenging area of photography appeals, there are plenty of books and courses available.

The only weddings I photograph are those of my friends and I make it really clear that I do it for fun only and no money changes hands. I go one stage further and only commit to taking the informal shots rather than all the formally posed ones of family groups. I take the approach that I am there as a guest not as the official photographer. On this basis, their expectations are not sky-high and the pressure on me is minimal.

This means, of course, that you may be shooting alongside a professional who is doing all the formal photographs. As a matter of courtesy and to avoid any aggravation it is definitely worth introducing

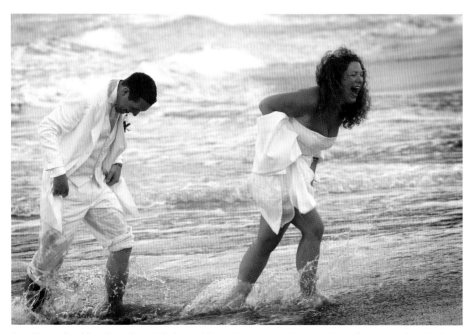

Formally posed wedding pictures have their place and that is what many people want, but be ready to capture those lovely candid moments too, which can sum up the happy occasion much more effectively.

yourself and making it quite clear you are not there to get in the way as they set up pictures or steal their livelihood.

Any bride and groom will tell you how much preparation is needed for a wedding and that should apply equally to you too.

Camera gear can, and does, go wrong so it is down to you to mitigate against such potential disasters. As the saying goes, if it can go wrong, it will.

Doubling up every single item of camera gear is clearly beyond the resources of most photographers and it is no fun lugging a huge bag full of gear to a friend's wedding. It is just a matter of commonsense so if something does go wrong you are not left camera-less. For example, if you are shooting digital, taking a film camera as a back-up is the sensible thing to do.

Being slightly paranoid helps. I will pack and check my gear the night before but I will still check that everything is fully charged and working before leaving home.

Great informal wedding pictures catch those spontaneous natural moments that sum up the joyous occasion. Being quick with the digital camera is obviously key to shooting such images, and this is where there is a potential obstacle.

Film cameras suffer from minimal shutter lag, which is the time delay between pressing the shutter release and the actual picture being taken. Sadly, this is not the case with many consumer digital cameras and shutter lag can be up to one second as the camera focuses and sets exposure. Clearly this time delay makes the difference between a candid, natural-looking image and one that is stiffly posed.

Always be prepared

Being aware of the problem helps and you just have to think even more in advance, but you may have to resign yourself to not getting images of great spontaneity. One thing that can help is using the manual focus option and relying on depth-of-field to get the subject sharp. The smaller size chip of most digital cameras means there is much more depth-of-field compared with 35mm film cameras.

Digital SLR cameras, on the other hand, do not suffer from shutter lag to the same degree as compacts and handle much more like their film counterparts.

On the technique front, I keep things simple. Exposure, focus and white balance are all left on automatic which frees me up to concentrate on looking for shots.

Outdoors, I have the flash turned off unless it is a bright, sunny day when the extra light softens the heavy shadows on people's faces to reveal detail.

Weddings comprise a sequence of events and there is not much time between them. Therefore, working quickly is essential and digital does have a big advantage in that you can see you have the shot before moving on. Mind you, while constant checking of the camera's monitor is reassuring it can also mean missing pictures, so I wait until there is a lull in the proceedings before doing a careful review and deleting any poor efforts.

Gear checklist

Camera
A digital SLR is ideal but a digital all-in-one with a decent zoom lens range is fine. Take a film SLR and film, just in case. With an SLR, a zoom lens (or a couple of lenses) covering the range of 28mm wide-angle to 105/135mm telephoto is perfect.

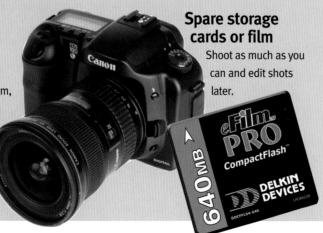

Spare storage cards or film
Shoot as much as you can and edit shots later.

A gadget to show your digital images on a TV
A simple device that is great for showing your friends what you have photographed.

Flashgun
Integral flash units are convenient but not especially powerful and a separate unit is preferable.

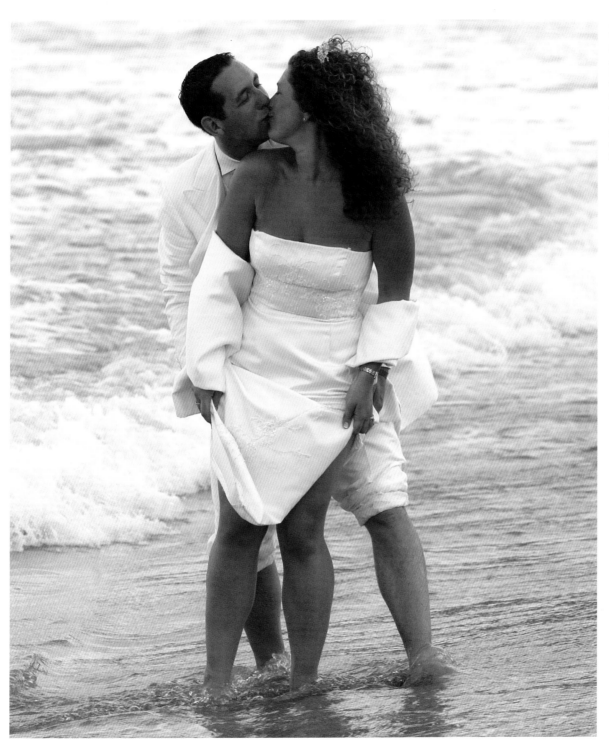

Fussy backgrounds can be very distracting, so before taking the shot always have a quick look around the viewfinder image. Changing camera viewpoint, selecting a wide lens aperture or using a telephoto lens, can all help to produce a less fussy backdrop.

Make a memorable montage

Tell a story with your wedding photographs by making a simple montage.

Start images

A good variety of images tends to give the most successful montages so pick out distant as well as detail shots. Be prepared to move pictures around, vary image sizes and alter presentation styles until you get a harmonious effect.

Step 1

START WITH A BACKGROUND Pick something that is appropriate but quite plain so that your images stand out. Resize to the size of the print you want to make. In this case, I wanted an A4 print so a size of 21x29.7cm with a resolution of 300ppi was set.

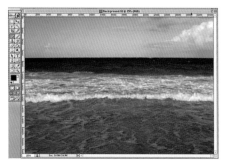

Step 2

PREPARE YOUR IMAGES Open images, adjust Levels, crop and go to Image›Image size and make images 300ppi. Add an Unsharp Mask.

Step 3

ADD A BORDER TO EACH PICTURE Go to Image▸Canvas Size and tick the Relative box. In this instance, a canvas of 1.2cm was used to add the border and the foreground colour was set to white. Press D first for a black border.

Step 4

TRANSFORM THE IMAGES Drag the images onto your background. You need to change size and orientation so go to Edit▸Free Transform (Ctrl T) to bring up little handles. Hold the Shift key and adjust the image size to suit. Confirm by pressing Enter.

Step 5

ADD A DROP SHADOW Go to Layer▸Layer Style and choose Drop Shadow or click on the small f icon on the Layer palette.

Step 6

HAVE A PLAY Adjust the Distance, Spread and Size settings to suit your taste. Try different Opacity and Angle settings too.

Step 7

STORE SETTINGS Once you are happy, store the drop shadow settings for use on the other images by going to Layer▸Layer Style▸Copy Layer Style.

Step 8

BRING IN YOUR PICTURES Click and drag over your other pictures and add a drop shadow after transforming by going to Layer▸Layer Style▸Paste Layer Style.

Step 9

FINALISE POSITIONING Once all the pictures are roughly in place, move them around. With the Move Tool selected, tick the Auto Select Layer box. This means you can move each layer by clicking on an individual image. Try moving layers around in the stack too. Finally, go to Layer▸Flatten Image. ■

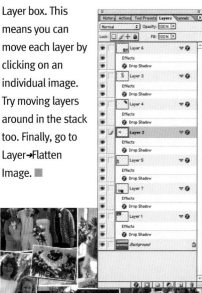

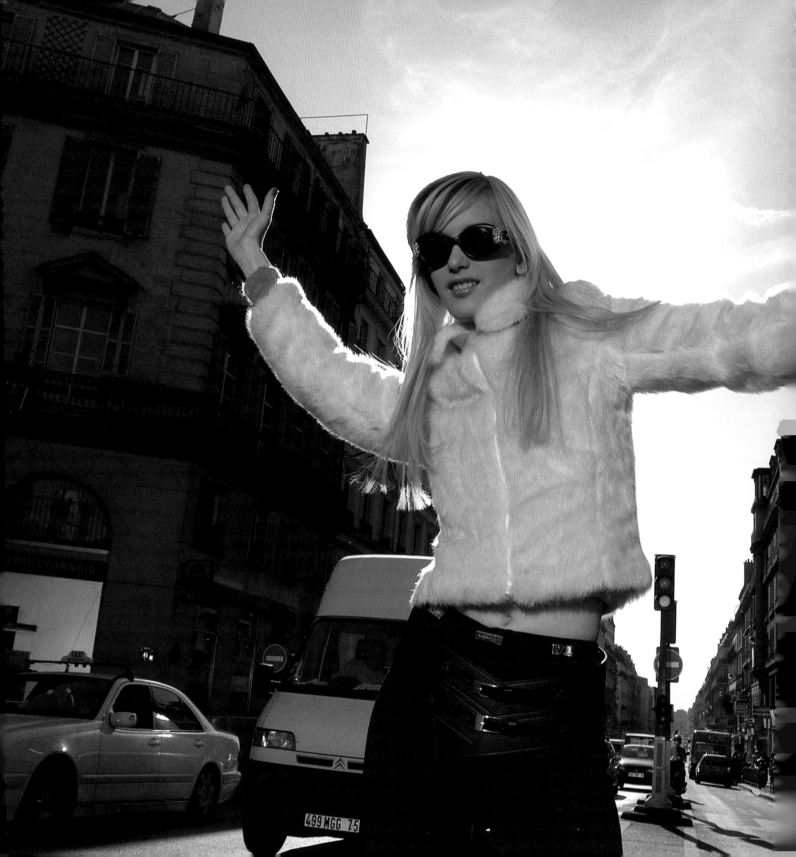

People portraits

Digital makes photographing people more fun than ever and getting great shots is within everyone's reach.

The immediate feedback of digital suits many subjects, but probably none more so than portraits. Literally moments after you have clicked the shutter you can check that your sitter had a pleasant expression and that they were not blinking.

Not only that, but with a computer and printer handy, your model can have a quality print in their hands minutes afterwards. Whether you are shooting commercially or for fun, this is a very powerful benefit of digital and should not be undervalued.

Photographing people well is a challenge that involves far more than pure camera skills. An ability to communicate and handle a broad range of different people is called for and not everyone can do this.

To get the most out of a portrait subject (and I am not talking about family snaps here), being able to relax your sitter for natural-looking images is important. This does not mean just your manner, which should be friendly and involving, but also the ambience of the environment.

You must remember that studio lights are alien beasts to most people, so you need to consider this and rather than spend ages fiddling with the technical stuff, you need to concentrate on your subject.

For me, though, the most important step on the way to decent portraits is having a 'vision' or an idea of how the final image will look in the first place.

High street portraits are straightforward but generally quite dull record pictures and if this is what you want, that is perfectly fine. Mottled brown or pretend 'library' backgrounds are still commonly found in studios up and down the land, with the ubiquitous fluffy white rug reserved for babies and toddlers.

Lifestyle portraits

There has been a move away from traditional sit there and grin portraits and that is very welcome. Many photographers are doing 'lifestyle' portraits and this is much more challenging and fun too.

Use daylight fill-in flash

Get serious about portrait photography and it is worth investing in a studio lighting outfit. Mains flash is a popular form of lighting and offers tremendous controllability, consistency and power on tap.

However, the world's best 'studio' lighting is the sun itself which is why I love shooting outdoor portraits.

Take, for example, these pictures here and on the previous spread featuring Viktoriya. It was a gloriously sunny afternoon and I decided to shoot into the light. True, lens flare was obviously a big concern but the bigger problem was the exposure. Taking a meter reading from her face and the bright background would have burnt out almost completely; rely on a meter reading from the bright background and Viktoriya would be a silhouette.

Consequently, I enlisted the assistance of a very powerful flash. A meter reading off an area of blue sky ensured that the dramatic lighting was not lost, while the flash lightened the shadows giving a dramatic portrait.

The lens aperture was set at f/11 and the flash was set manually to give an output that would suit f/16. This extra lighting made the model stand out from backdrop.

The picture was done in a hurry because I was out in the middle of the road and I did not even bother with a meter reading. I just took pictures and checked the results on the digital camera's monitor. A couple of test shots was all that was needed.

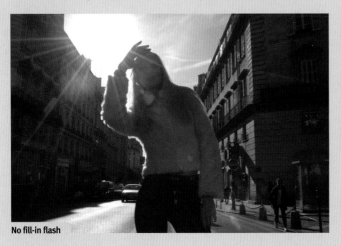
No fill-in flash

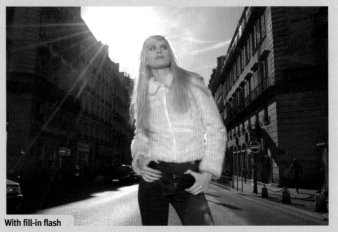
With fill-in flash

Lifestyle images capture the subjects looking more comfortable and less posed, doing day-to-day things in natural surroundings. Portrait photography on the hoof like this is great fun and offers huge creative potential. You choose the most suitable location (usually outdoors) as well as appropriate clothes and props, and this is on top of how you decide to photograph it.

Lifestyle sessions should be fun and digital capture means you can keep the energy levels high because you know when you have got a particular shot and can move on.

Setting up the digital camera appropriately for the session is worth a few minutes. If you are aiming to make large prints, setting RAW image mode rather than fine JPEG is advised. On the other hand, some cameras in RAW mode limit you to one shot every few seconds or perhaps a burst of four frames before freezing up as the camera writes the images to the media card. Therefore, if it is a lively session, using a JPEG mode might be better.

You also need to think about the camera's ISO sensitivity and white balance settings, preferably before the session. Digital cameras are very flexible but you want to keep the

amount of time you spend adjusting it during a shoot to the minimum.

Generally speaking, set the lowest ISO speed practical in the lighting conditions to optimise picture quality. In other words, the chosen ISO should allow shake- or movement-free images. The white balance control can often be left on automatic but try tailoring the setting to the situation. Shooting with windowlight, for example, you may get more attractive, warmer-looking results using the shade or cloudy setting.

Work on ideas

I have concentrated more on the techniques of digital portrait photography here but, as I mentioned earlier, the biggest challenge is usually having great ideas in the first place.

I collect tearsheets from newspapers and fashion magazines and keep them in a scrapbook to help me think of portrait ideas. This is not to say I plagiarise ideas wholesale but rather I use the imagination of other people to get me thinking, especially about different lighting and technique approaches.

If you want to take your portraits to the next level, I can thoroughly recommend this idea and before each shoot flick through your scrapbook just as a refresher.

Thanks to...

Magali Gless of Ford Models Europe for permission to use these pictures of Viktoriya. Big, big thanks also to Jonns and Ursula Frégence of Focus Image (www.focusimage.com), without whom the session in Paris, and hence these images, would have never happened.

How to add a touch of class

Harsh studio lighting does not suit every portrait style, and adding a slight hint of diffusion is definitely worth the effort.

Most image manipulation softwares have several methods of diffusing your images. This one method, in Photoshop 7.0/CS offers considerable controllability and gives a lovely effect without dulling the highlights or weakening any shadows.

Step 1

DUPE YOUR LAYER Start by making two duplicate layers. Do this by clicking on the Background in the Layers palette and drag it onto the new Layer icon while holding down the Alt key. Name these layers as 'a' and 'b' for easy reference.

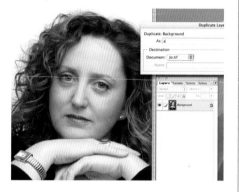

Step 2

BLUR THE LAYER Let us start on the 'a' layer. Click on it to make it active then go to Filter→Blur→Gaussian Blur. Here, making sure the Preview box is ticked, set a radius of 20 pixels. Click Okay. This amount of Gaussian Blur heavily diffuses the original .

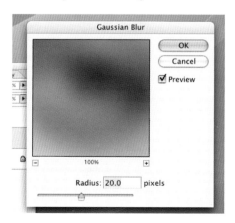

Step 3

USE LAYER BLEND MODE Go to Layer Blend mode and click on the tab, which brings up many options. Select Lighten.

Step 4

ADJUST OPACITY Next click on the Opacity slider and reduce the amount of blur. In this example, a setting of 50% was used.

Step 5

ON THE 'b' LAYER Repeat step 2 but this time reduce slightly the amount of blur you set, then as in Step 3, go to the layer blend mode menu but this time set Darken.

Step 6

MAKE THE FILTER To put the filter into one Layer, start by making a new layer. Click on the layer icon to make a new Layer which can then be renamed 'filter'.

Step 7

MERGE LAYERS Click on the eye symbol to turn off the background, then go to Layer→Merge Visible. This brings layers 'a' and 'b' into one, which is your diffusion filter. The actual layers 'a' and 'b' can now be dumped. Use the opacity slider to reduce the effect of the filter to suit your taste. ■

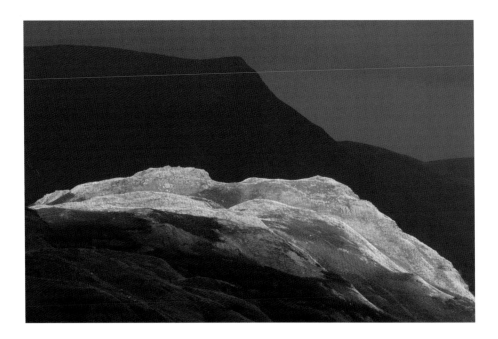

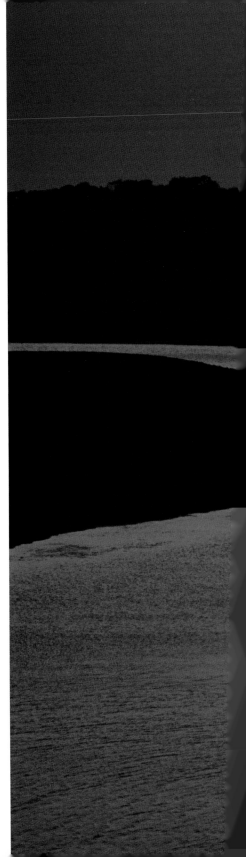

Landscapes

Head for the great outdoors for a breath of fresh air and landscape photographs that you can be proud of.

Shooting landscapes is the most popular subject among photographers. Its immense popularity is due to any number of reasons: easy accessibility, the challenge, the chance to appreciate beautiful countryside, the feeling that it is easy and the immense satisfaction when everything goes according to plan, are just some I can think of.

This is a broad subject category and it is not always the case that landscape pictures are landscape in the purest sense. Man-made intrusions are almost inevitable and often cityscapes and streetscenes get grouped together as landscapes.

Whatever your take on the subject, there is no doubt that good landscape photography is a challenge and demands commitment for successful shots.

At one extreme, it is tumbling out of a tourist coach at some beauty spot for a few quick snaps. At the other, it is the challenge of finding fresh locations, waiting for the right season and then getting there when the light is at its best. And of course you can plan all you like and find on the day itself that the sun stays stubbornly hidden behind heavy clouds or all the trees have lost their leaves the night before.

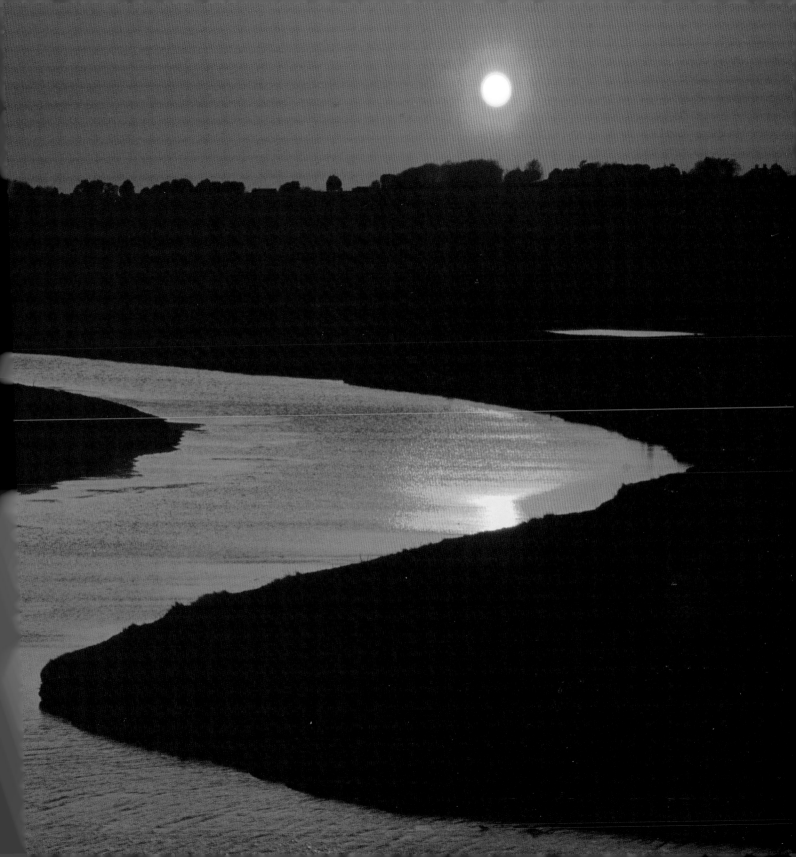

Learn to compose

Composition is a subjective science. Here are four guidelines which can help and these can work for every subject, not just landscape. But they are only guidelines and do not have to be slavishly followed.

The rule-of-thirds. Just imagine the viewfinder image split up into thirds by a series of imaginary lines. To compose according to the rule of thirds, place the horizon or something prominent within the scene either on one of these lines or at an intersection. This is an effective guideline simply because it gets the main subject away from the centre of the frame.

Use a focal point. Pictures without a prominent point of interest can be quite dull and only hold the viewer's eye for a very short period.

Foreground detail is important. It is easy to become drawn to lovely distant detail and to overlook what is right at your feet. Select a small lens aperture for maximum depth-of-field. An eye-catching foreground, crucial with wide-angle lenses, gives a solid base on which to build the rest of the image. Look for lead-in lines. Strong lines within a scene will draw the viewer into the photograph. These lines might be a fence, a river, a line of trees or reeds in the foreground.

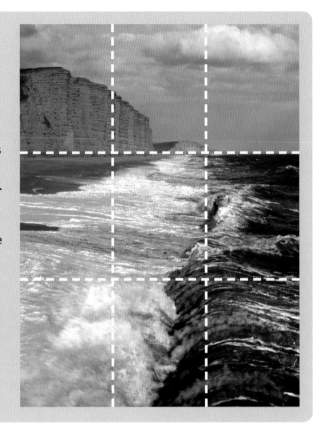

Landscape pictures often benefit from the application of the rule-of-thirds. You can see how this coastal shot conforms to the rule for a lovely, balanced composition.

It is worth noting that a breath-taking view does not necessarily make for a breath-taking photograph. Remember, you are trying to translate the grandeur of a huge, stunning vista to a small print.

Good scenic photography does need working at and it is not as simple as some people might have you believe. It is easy to be carried away by a stunning view and overlook the cornerstones of competent composition. You still need to look for a focal point, strong foreground, lead-in lines to grab the viewer, great light and so on.

Where many landscape pictures fail is on poor composition. How you use the elements within the scene needs careful consideration and it is not good enough just to pick up the camera, frame up the picture and snap away.

Practice composition

The temptation to do exactly that is there with digital photography, especially with compact cameras, which have tiny viewfinder eyepieces and hinder rather than aid better composition.

Using the camera's monitor is better because of the larger image but there are inherent problems here too. Battery consumption increases and on a sunny day seeing the image can be difficult, so you need a monitor viewing shade.

Above all, it pays to look at pictures by experienced landscape photographers to see how they tackle composition. Applying what you have learnt is one thing, being honest and critical once you have the final pictures is another and this is a skill you must learn. You will soon pick up on what is pleasing to the eye and what is not.

In terms of practical advice, I suggest that you always scan around the whole viewfinder before taking the picture. If you feel something is not working hard enough or there are too many distractions in the frame, use your feet and move, alter the camera's height or switch lenses. The brain and feet are powerful tools, so use them.

Using filters

Many on-camera filters have been made redundant with the advent of digital. With software, replicating the effect of some camera filters is relatively easy and, to be honest, quite convincing. Filters such as soft-focus, warm-ups and contrast filters for black & white can be simulated quite effectively.

However, there is one filter beloved by landscape photographers that is difficult to accurately replicate in software. I am talking about the multi-skilled polarising filter. The polariser does several jobs. It intensifies blue skies, cuts down glare which helps to saturate colours and it helps control reflections off water. A polariser is also an effective neutral density filter because it can down on the amount of light reaching the film without affecting the picture's tonal relationships.

The lighting at either end of the day can be wonderful and making the extra effort to get up early or to stay out late will soon pay dividends.

Merge skies for perfect exposure

To help control contrast between a dark foreground and a bright sky, landscape photographers use graduate filters at the time of taking. Digitally, there are other options.

The Lake District was the location for this shot. It was a lovely, pastoral scene but dull until suddenly the sun broke through the clouds. The strong light brought out texture and added sparkle to the scene.

But I knew the contrast range was beyond that possible with a straight shot, so I quickly took two images within seconds of each other. One was exposed for the foreground at 1/250sec at f/8; the other exposed for the sky highlights at 1/1000sec at f/8. My plan was to take the foreground of the former and combine it with the backdrop of a dramatic sky from the latter.

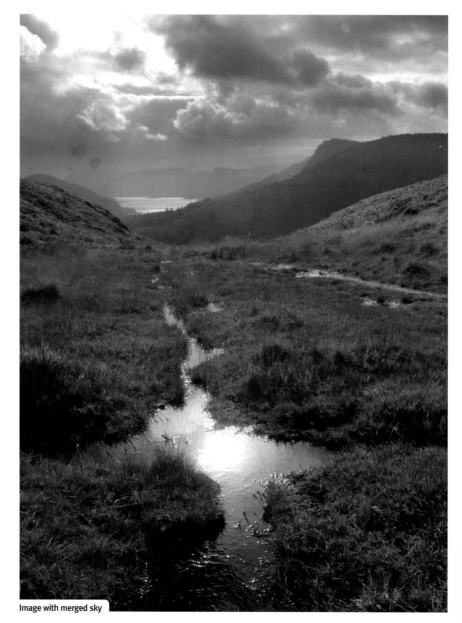
Image with merged sky

Start image: highlights

Start image: shadows

Step 1

PREPARE YOUR IMAGES Open the images and do any tidying up and Levels adjustments the images might need.

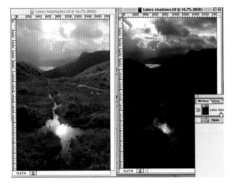

Step 2

MOVE THE IMAGES Select the Move Tool and click on the darker image and drag it over completely so that sits over the lighter image. Close the original darker image.

Step 3

GET THE RIGHT POSITION The images are nearly identical, but not quite. For accurate positioning, select the Overlay mode in the Layer palette and magnify the image (Ctrl and + key) and use the Move Tool.
Crop off any part of the image which is not overlapped. In the Layer palette menu go back to Normal mode.

Step 4

CHOOSE THE SKY Click on the bottom right corner and pull out to expand the canvas. Choose the Polygonal Lasso Tool and make a rough selection of the sky area.

Step 5

GIVE IT SOME FEATHER
The selection is very obvious and needs softening using the Feather Tool. Go to Select→Feather and in this case I set 100 pixels.

Step 6

INVERT THE SELECTION The sky in this image needs to be protected ready for Step 7, so the selection was inverted by going to Select→Invert or Ctrl, Shift and 'i'. Clicking on the Quick Mask lets you see your selection.

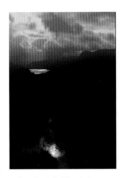

Step 7

ERASE THE FOREGROUND Select the Eraser Tool and a big brush around 500 pixels, then start erasing the dark foreground to reveal the lighter foreground behind.

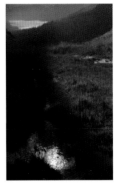

Step 8

THE FINAL STEP Go to Select→Deselect to lose the selection and finish the shot by going to Layer→Flatten Image. ∎

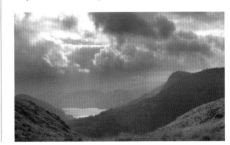

Natural world

Digital capture means you know you have the shot almost instantly and when it comes to nature photography this is a serious advantage.

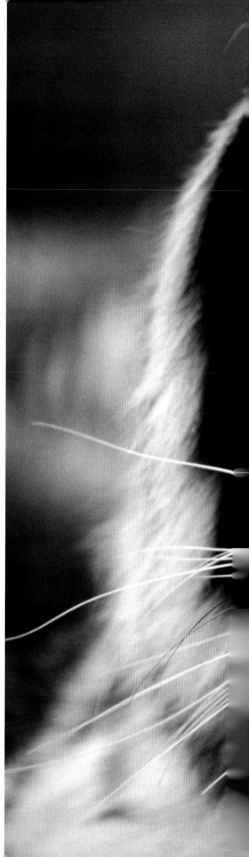

The immediacy of digital is an obvious benefit but another huge advantage is less obvious.

The majority of digital SLR cameras use a sensor chip that is smaller than the 35mm full-frame film format. In practice, fit a lens designed for a 35mm film camera on a digital SLR and there is a magnification increase.

It is important to stress that there is no actual change in the lens's actual focal length and the image it produces is identical. It is simply that the same image size on the smaller digital chip gives an effective magnification increase.

With most digital SLR cameras this magnifying effect is in the order of 1.5x. Thus, a 300mm long telephoto focal length on a 35mm film camera becomes an effective 450mm lens on the digital SLR.

When it comes to photographing nature, when almost invariably the subject is some way from the camera, this is a welcome boon. In short, it means you get the pulling power of a longer lens without the disadvantages of extra weight and bulk

So, whether you are into snapping birds in the garden or big cats in the Masai Mara, having this extra punching power with your telephoto lenses can make a real difference.

Handle with care

However, telephoto lenses demand respect and sound photographic technique is important to make the most of this potential, otherwise your images will be ruined by camera shake and poor focusing.

Modern autofocusing systems are accurate and responsive but are much less effective at smaller apertures. With long telephoto lenses having a maximum aperture of f/5.6 or slower, the camera might need manual help.

Wildlife parks and zoos offer good photo opportunities but you need to look around for the best camera angles to avoid messy backgrounds and to throw any caging or bars out of focus. A 300mm lens was used for this image of this tiger.

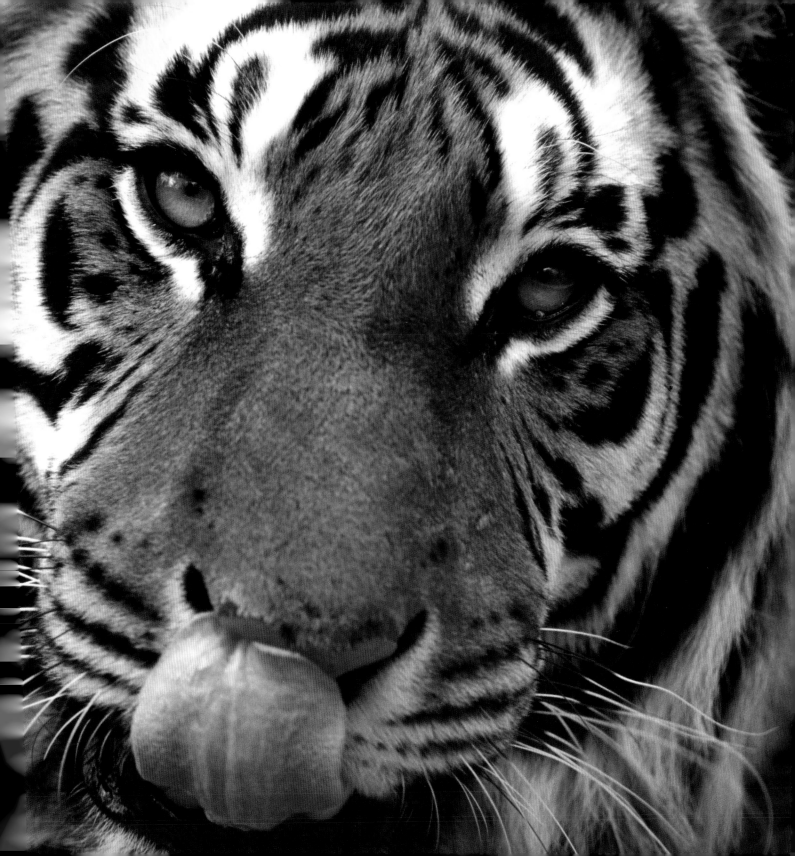

In fact, you might be better off engaging manual focus to avoid missing crucial moments. However you focus, take as much time as you need and use any available focusing aids in the camera's viewfinder.

The other factor here is the limited amount of depth-of-field with longer focal length lenses. A subject, say at a distance of 10 metres, and a 300mm telephoto lens used at a wide aperture means the amount of front to back sharpness might only be a few centimetres. With depth-of-field this shallow you can see why focusing is so critical. One benefit to come from this is that any distracting background will be nicely thrown out of focus.

Equally important as critical focusing is shutter speed selection. With a 300mm lens, the theory is that the absolute minimum shutter speed for safe hand-holding is 1/300sec, or the nearest setting, but I reckon that this can be misleading and a minimum speed of 1/500sec is much more realistic.

With most digital SLRs, there is the temptation to hand-hold the camera at relatively slow shutter speeds because there is less vibration, thanks to a smaller reflex mirror.

I mention this because I have fallen into this trap myself. Yes, there is less vibration, but there is still enough to cause camera shake, so try not to be lulled into a false sense of security. Take every precaution you need to, including using a tripod, otherwise you will be disappointed with your work.

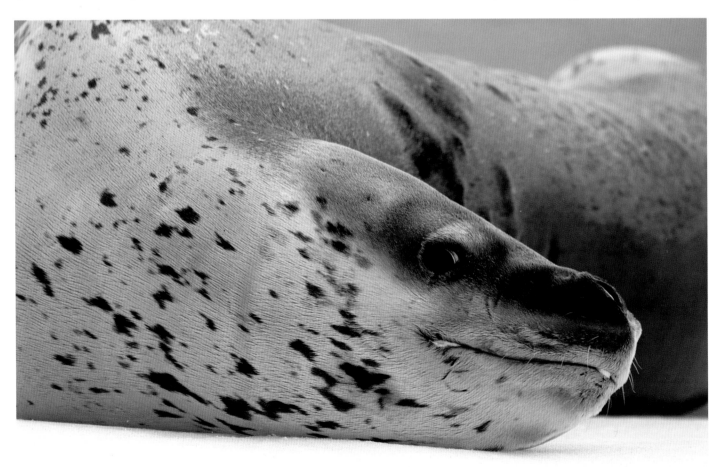

Use a support

Frankly, I am amazed by the tripods some photographers end up buying. To be frank, many cheaper, less stable models are not even worth using and induce rather than eliminate camera movement.

Low cost or lightweight models should only be used if it's very still and with modest camera/lens combinations. Wind, big cameras and long lenses are almost sure to result in blurred pictures unless very fast shutter speeds are selected.

My current tripod is made from carbon-fibre, so it is much lighter than equivalent aluminium models but still gives excellent stability. The disadvantage of carbon-fibre tripods is that they are expensive, but I have found the investment easily justified by the number of times it has been used.

Where stable tripods can be compromised is by the tripod head. This is the crucial link between tripod and the camera and demands careful consideration because a poor head is a serious weakness.

Tripod heads are available in a wide variety of types. Some are slow and awkward to use, which is the exact opposite of how they should be. Worse still, some are poorly designed and engineered.

In my experience, the most common weakest link is the quick release system. Its purpose is clear and the system should let you switch quickly between cameras or allow you to set up rapidly without compromising on stability.

Sadly, some quick release systems are not worth having. I use a system that features a camera plate that can be really firmly attached to the camera or lens. It is also a metal system which gives excellent stability.

What to look for in a tripod

The tripod is an invaluable but often underestimated accessory and it makes sense to buy the best one you can afford in the first place. Here are some of the key factors to consider.

Head

This is probably the single most important aspect of a tripod, which is why some top-end models come without one so you can choose the one you want.

Points to consider: a firm camera fixing, a firm quick release mechanism, allows vertical as well as horizontal shooting, locks securely into position and is fast to use.

Maximum extension

The ideal is a solid tripod which will let you shoot at full standing height without crouching and with minimal centre column extension. Using too much centre column extension will lead to greater risks of camera shake.

Leg locks

Two methods are commonly used: lever or twist-grip locks. They should be comfortable to use, even in the cold with gloves on, as well as locking the legs firmly into position. Even better is if you can dismantle and clean the locks.

Feet

Rubber feet are fine for most occasions but some models offer the alternative of spikes.

Splayed legs

A very useful feature that allows the tripod's legs to open out further for a lower shooting position. Also useful for support in awkward positions.

Carrying strap

A tripod is only useful if you have it with you, hence you need a comfortable carrying strap.

Versatility

Some tripods let the centre column be switched from its standard position and be mounted laterally or upside down for a very, very low camera viewpoint.

Using the RAW converter

Competent software processing is crucial to make the most of shooting RAW quality files.

Most top-end digital cameras have the option of shooting RAW format and if you want the best possible image quality, this camera setting is the one to use. This mode records the image with no in-camera processing.

RAW image files need to be processed in software into a form that is readable by image-editing software. However, some imaging software, like Photoshop CS or Photoshop 7.0 with the appropriate plug-in, can process RAW files.

It is during this RAW image processing that the photographer can exercise considerable post-shooting control. How much flexibility depends on the software. Usually, exposure and colour balance can be adjusted but also colour saturation, white balance and sharpness can be modified.

In this example of a blue-eyed cormorant taken in the Antarctic, the original was taken on a Canon EOS 10D and inadvertently underexposed by one stop.

In Canon's image processing software, the RAW file was processed with default settings and you can see the white tones are poor, just as you would expect from underexposure. Levels or Curves in Photoshop can be used to redress this but this will mean affecting other areas of the tonal range.

More information can be gleaned in the processing of the RAW file and with Canon's RAW software utility it is easy to correct for this underexposure for a fine image.

How it works

Preview the images
Thumbnails make life easier checking your images.

Compensating exposure
Move the slider and check the preview image to see the effect. Continue making adjustments until you are happy, before changing the image to JPEG or TIF format.

Find your pictures
Organising your RAW files and puting them in one folder will speed things up.

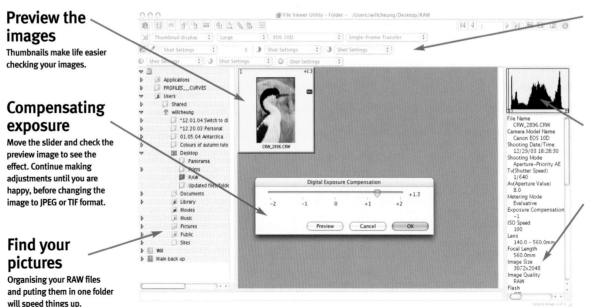

Tools
RAW software lets you take control of important aspects of the image, including colour casts, white balance and sharpness.

Exposure histogram
A graphic representation of the image's tonal values.

Shooting data
Every aspect of a RAW image, including exposure settings, metering mode and lens focal length, is stored in the file for future reference.

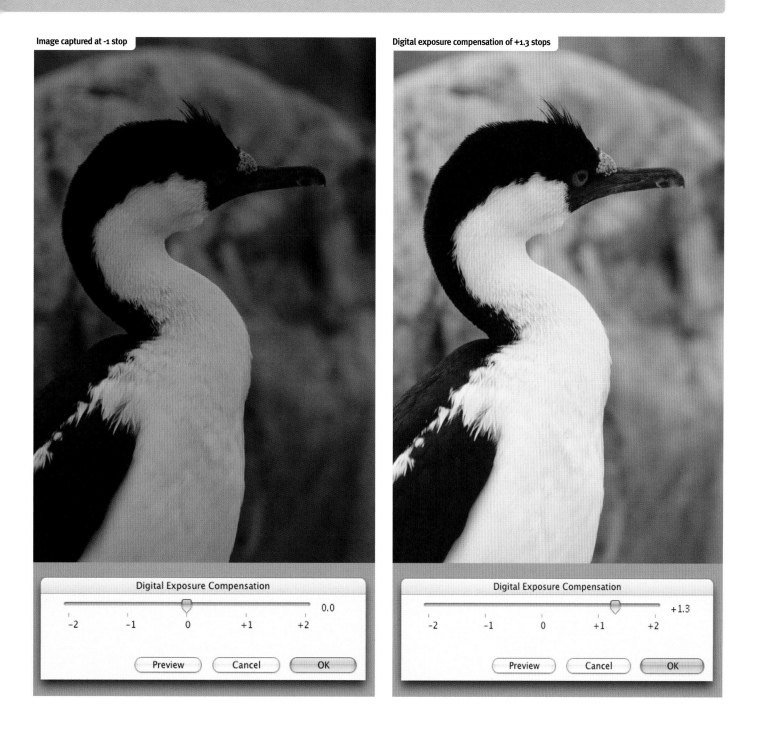

Image captured at -1 stop

Digital exposure compensation of +1.3 stops

Digital Exposure Compensation

-2 -1 0 +1 +2 0.0

Preview Cancel OK

Digital Exposure Compensation

-2 -1 0 +1 +2 +1.3

Preview Cancel OK

Sports & action

If there is one photographic subject to get the adrenaline pumping and the shutter finger twitching, this is it.

If you want a subject where superb hand to eye co-ordination is crucial, try sports and action photography. But before you start fantasising about rubbing shoulders with the rich and famous, let me say now that great action photography can be done in the local park – and it is just as challenging.

Whatever the subject or venue, the ability to operate a camera decisively, quickly and instinctively is important. Fumbling around means missing photogenic moments forever. Second chances in this type of photography are few and far between.

The first thing is to get to know your camera. And I mean really, really get to know your camera. Tracking a subject hurtling towards you through a telephoto lens, aiming for a clean composition and keeping the subject in focus all at the same time is far from easy, and you need to work instinctively.

Of course, a great deal depends on the action you intend photographing and you have to apply the right technique to the subject. For example, the shutter speeds required for shooting athletes running round a track are very different from trying to 'stop' high-speed motorsport.

There are also the various issues in getting a good camera position and so on, which is why if you like the idea of photographing sport you should start out at a local level, learn all the skills required and work up.

Getting it right

The key things to get correct, just like any form of photography, are both technical and aesthetic. Pictures should be well composed and not cluttered and, naturally, they should be perfectly exposed and sharp. And if shots are not perfectly sharp, any deliberate blur should be obvious to the viewer.

Using the latest metering systems, correctly exposing a picture is easy enough in frontal lighting. It is only in extreme backlighting that a system might fail and in such cases you may have to lend a hand and increase the amount of exposure.

For most subjects, I favour aperture-priority autoexposure but I make an exception for action photography and switch to shutter-priority AE. Choosing a suitable shutter speed is important with this subject.

The situation with focusing is less straightforward. Most photographers use

Use a monopod for extra support

Using a tripod is not practical for sports and action work because it is too slow and cumbersome to use.

A much better option is the monopod. This one-legged support gives good stability, but permits plenty of flexibility in the horizontal plane, which means 'panning' or tracking a fast-moving subject through the camera viewfinder is easy.

Good technique is important if you are to make the most of the monopod's potential. To maximise stability, use the monopod's single leg and your own two legs to make a kind of 'tripod'. Do this and you get excellent stability while still being flexible enough to react to a fast-moving subject.

autofocus and for many subjects modern systems can keep up and give accurate focus. But with action, where by definition things move and change quickly, autofocus is not quite so dependable.

In bright light with a subject with plenty of strong lines, an autofocus system might be able to keep pace as the action moves into frame. But from my experience, I know most cameras cannot keep up and the lens might end up tracking back and forth with the subsequent loss of the decisive moment.

Therefore, I would say it would be better to switch to manual focus and use a technique called 'pre-focusing'. This is manually focusing on a pre-determined point – say a mark on the racetrack – and then taking the picture an instant before your subject gets to that point. The shutter has to be released a

fraction early because all cameras suffer from shutter lag, which is the slight delay between pressing the shutter release down fully and the actual exposure being made. This delay is due to the camera having to perform certain functions before the exposure is made.

Digital cameras suffer from shutter lag much more than film cameras. With consumer compact cameras, this shutter lag is very noticeable and can be as long as a second or more. While this might not sound long, even with simple snapshots it can be the difference between getting the shot and missing the moment completely.

For action work, shutter lag of this level is impossible to deal with. Fortunately, digital SLR cameras suffer less compared with their compact cousins, but you will find that there is even less lag with film cameras.

So if you use pre-focusing technique, release the shutter a mite earlier than you would do with a film camera. Checking the monitor and using the zoom magnifier, if it has one, will tell you how accurate you are.

Lens options
Most sports happen some distance from the spectators which is why long telephoto lenses are standard for action photographers. The great news here, if you are shooting on a typical digital SLR is the lenses you own for your 35mm film camera effectively have more telephoto power. I have discussed this in more detail on page 72.

In motorsport, football, cricket and the like, having the extra reach of longer telephoto lenses can make all the difference in helping you achieve tightly composed shots.

With long lenses comes the risk of camera shake, so a camera support is essential. Here it is worth making a point about the difference between camera shake and subject movement. Camera shake is the camera and lens moving during the actual exposure while subject movement is self-explanatory. In action work, there is the risk of both – individually and in combination – but while any subject movement is acceptable and gives pictures that have dynamism and a sense of speed, camera shake is not.

A tripod is not practical for most sports because they are simply too slow to use, and the much better alternative is the monopod. With one of these, you stop the lens waving around without compromising the need to move around freely.

Panning technique is popularly used by action photographers and with a suitable shutter speed the result is a sharp subject against a blurred background. Panning is keeping track of the subject in the viewfinder and releasing the shutter as you 'pan' with

You can hone your skills without making the effort of going to a major sports event. Even a fairground ride can be a great opportunity and a good time to experiment.

the subject. Pan correctly and the subject stays sharp while the background is blurred because you were moving the camera – in a controlled manner – during the exposure. This technique needs practice, especially with very fast-moving sports like bike and car racing. But get it right and it is a great way to give the impression of movement, so it is a valuable technique to practice.

Making more of action

If your action photographs lack excitement, use the computer to add some much-needed zing.

Sports photography is a challenge in many ways. Capturing the moment in-focus, dealing with messy backgrounds and getting shots that look exciting are just some of the obstacles. Take this photograph taken at Rockingham Raceway. I managed to get it sharp, which was one thing. I also got the tight crop I wanted using a 300mm lens. But I felt the result lacked impact until I tinkered with it in Photoshop 7.0/CS.

Original image

Manipulated image

Step 1

OPEN THE IMAGE Click and drag on the corner of the canvas to give yourself more room. Choose the Polygonal Lasso Tool and make a selection by clicking your way round the car. Double-clicking at the end joins the selection.

Step 2

FEATHER IT The selection will be harsh, so go to Select→Feather soften the edges. Here I feathered by 40 pixels.

Step 3

INVERT THE SELECTION The car is fine and it is the background that needs help so I inverted the selection by going to Select→Inverse.

Step 4

ADD THE FILTER Time to blur the background. Go to Filter→Blur→Motion blur and vary the settings. I went for the maximum distance setting of 999 pixels.

Step 5

TIME TO GO MONO I wanted the car to stand out, so with the same selection in place I went to go to Image→Adjustments→ Desaturate to make the background mono.

Step 6

ADJUST DENSITY The background was very grey so I went to Image→Adjustments→Levels to intensify it. Finish with Select>Deselect. ■

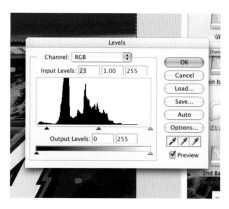

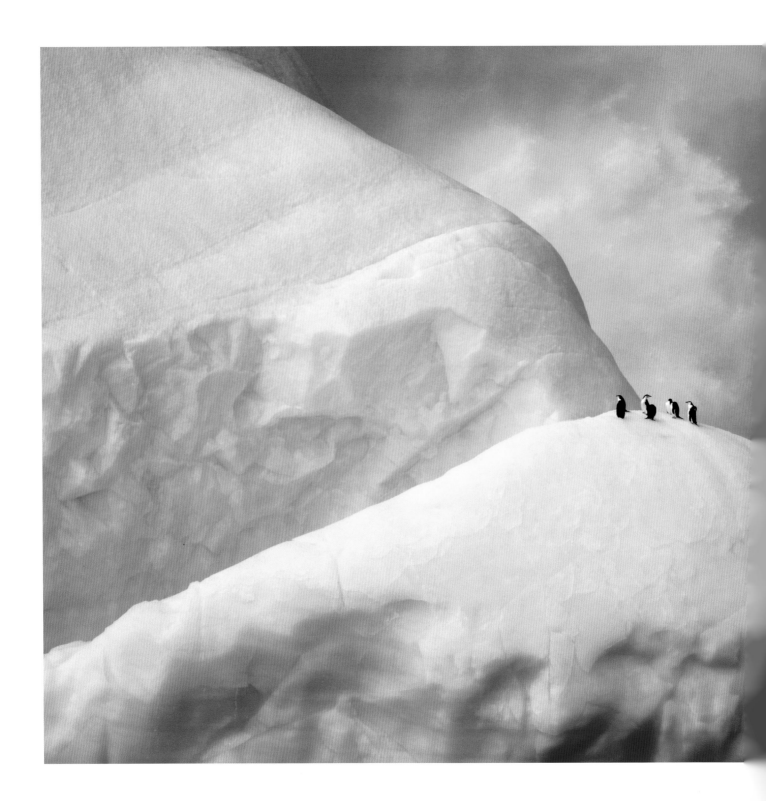

Travel

Gearing up for travel photography with a digital camera is not much different from taking a film camera. However, there are several factors that need extra consideration.

Many of the disciplines and demands of travelling with a digital camera outfit are obviously similar to those of film photography. But there are differences, especially on the support side. Spare batteries, extra memory and a back-up pocket album are standard in my travel outfit for obvious reasons.

I will be honest and say that I have not yet done a digital only trip when photography was top of the agenda. The security blanket of a film outfit has always gone with me. I still find it strange relying on these little, easily lost storage cards rather than film.

Trust is something that has to be earned and over the years I have gotten used to travelling with film and have a system I am very familiar and happy with.

I did a big, once-in-a-lifetime trip recently to Antarctica and clearly there was no way I was going under-prepared, so I took plenty of film and digital gear. In the end, I had bags of film, my own battery mountain, pocketfuls of memory as well as a laptop and all the other required paraphenalia.

On the camera front, I took one digital SLR body and two film bodies, plus four lenses: a 17-40mm wide-angle, a 28-135mm standard zoom and two telezooms, a 70-200mm and a 100-400mm. As you will appreciate, by the time a tripod and so on was gathered together, this was a sizeable outfit and I had to pack many items in the hold baggage because the weight was way over the allowance for hand baggage.

One great thing with digital is that you no longer have to worry about the affect of X-ray security checks at airports because X-rays cannot 'fog' images stored on flash memory. There is also no problem with computer hard drives and MicroDrive cards although, in theory, very strong magnetic fields will damage the data.

Travelling light

For me, the really great thing with digital media is that it takes up so little space. Half-a-dozen CompactFlash cards is smaller than a single film cassette and if they are high capacity you can take hundreds and hundreds of high resolution pictures, which is a huge benefit. Also, with film you may pack a variety of speeds in colour slide, colour print and monochrome and that takes up a great deal of space too. With digital, there is no need to worry about this either.

It is among the supporting accessories that you will think have to think about carefully.

On my long-haul trip to Antarctica, for the first time on my travels, I decided to take a

laptop computer. I figured it would be handy for downloading storage cards as well as for viewing and tweaking images during the long bouts of travelling.

The laptop was useful but next time I probably will not bother. It took up too much space and weight and I was happy downloading pictures into the standalone portable hard drive I had with me.

Downloading storage cards is a major issue and one that needs serious thought. The easiest way round the issue is to invest in a digital photo album. There are many on the market, offering a range of storage capacities and features. The best ones have a small integral colour monitor which means you can visually check that images have been transferred over successfully. See the panel below for more advice on picture storage devices.

Power is another concern. Modern cameras, whether film or digital, are battery dependent so we have all gotten used to packing spare cells and chargers.

Digital can be more involved. You may need one battery charger for one camera and a different one for another model even if they both come from the same manufacturer. Then you need leads and mains adaptors too and before long you have to start taking out clothes to get in your digital odds and sods.

Travelling digitally can mean you end up with much more stuff than travelling with film. However, think about it carefully and you should end up with an oufit that will not leave you exhausted before you even get to your destination.

Storage on the move

Storage cards are getting cheaper all the time, but on a busy shooting trip you will have to think about the amount of memory you have and how it is managed. This is even more important when shooting high resolution JPEGs or RAW files.

Strict editing of shots is always advised but you might not want to delete any images until you get home. Therefore, it is worth having a storage device to download images from your cards so you can carry on shooting without any restriction.

Memory devices are available to work via the computer as well as standalone units that allow image download on their own. Which option suits you depends on how you travel as well as your budget or you might want to consider both to cover all eventualities.

Portable CD writer
These battery-powered, standalone devices accept all common card formats (usually via adaptors) and write images direct to a standard CD-R disc. With CD-R disks currently accepting up to 800Mb of data this is a practical and sensible way of backing up images. Not

only that, but CD-Rs disks are cheap and so making two identical disks (one as back-up) of your shots is no problem.

Photo wallet
A photo wallet is basically a portable hard drive designed to accept images downloaded direct from camera media cards. They can work as standalone units or connected to a laptop. More sophisticated models have small, high quality colour monitors to check images and features such as slide show for automated image previewing.

Portable hard drive
If you travel with a laptop, an extra portable hard drive is worth considering. It will plug straight into the Firewire or USB port on the computer and most models have seriously large amounts of memory.

How to save your images

Every digital camera writes images as JPEGS on the storage card but many more advanced models also have the option of RAW or TIF modes, so which should you use?

RAW is literally all the data straight from the camera's CCD chip without any in-camera processing. This is the mode to use when ultimate image quality is of paramount importance. On the downside, you'll get fewer images on a card compared with JPEGs and writing images to RAW does take longer. When you get to the computer stage you will have to open files using a RAW converter program, which is usually supplied with the camera, or buy a plug-in for Photoshop 7.0. Photoshop CS has a RAW converter built-in.

TIF is a lossless format and takes up even more space than RAWs on the storage card so you get fewer shots. On the plus side is that most image-editing programs will open TIF files without any special plug-ins. TIF files give very high picture quality although they will have been processed by the camera's software.

JPEG is a lossy format but it does give the most shots per card and writes images comparatively quickly.

Fixing underexposed images

Shoot into the light and there is the risk of underexposure and that is what happened here.

This sunrise picture taken at Uluru in Australia is spot-on if it is highlights you want. Shame about losing all that detail in the foreground desert sand.

I had decided to shoot Uluru facing directly into the sunrise. This meant contrast problems. The contrast range from the bright orb of the sun to the dark, unlit foreground was a great many f/stops.

Exposing with a meter reading from the foreground would mean the sky bleaching out, while exposing for the sky would lose foreground detail.

I could have used a few graduate filters in combination to help balance contrast but there was little time. In the end, I exposed for the sky and then set to work on the computer to sort the film image out.

Start image

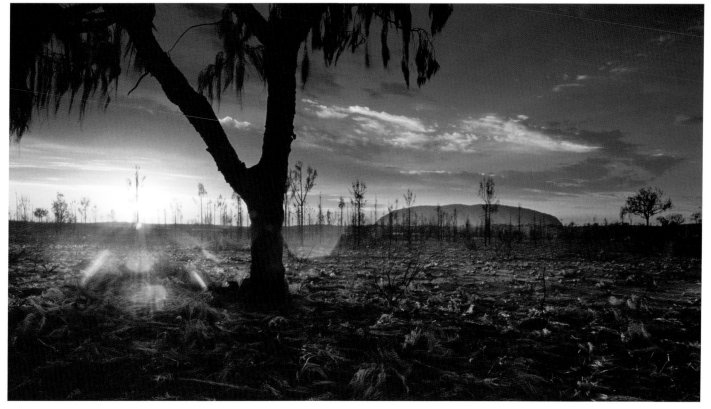

Step 1

I started by making a background copy. Click on the background and drag it onto the layer icon, or go to Layer→Duplicate.

Step 2

I picked the Polygonal Lasso Tool and selected the area of blackness. In other words, virtually the whole of the bottom half. A graphics tablet makes selections easier but I used a mouse.

Step 3

Photoshop has a Quick Mask feature found towards the bottom of the Tool Palette. Use this to check selections. Here, the basic mask has a very sharp edge and needs modifying.

Step 4

The mask was softened by using Feather. Go to Select→Feather to bring it up, then it is time to have a guess. I tried 60 pixels to start and then used the Quick Mask to check the effect.

Step 5

This is how the selection looks after feathering. As you can see the effect is much more gradual.

Step 6

Now I wanted to adjust the 'exposure' of the selected area so I went to Layer→New Adjustment Layer→Levels. Clicking OK brings up the Levels control automatically.

Step 7

All the tonal range is condensed at the shadow end and there is nothing in the mid-tones or in the highlight areas.

Step 8

Adjusting the mid-tones and highlight arrows has a dramatic effect on the selected foreground area. Confirm by clicking OK.

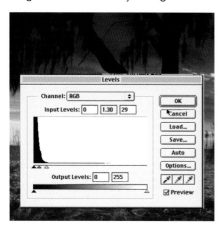

Step 9

Go to Layers→Flatten Image so that the multi-layed image becomes one. I finished off by adjusting colour balance and taking out some of the image's redness. Go to Image→Adjustments→Color Balance. ■

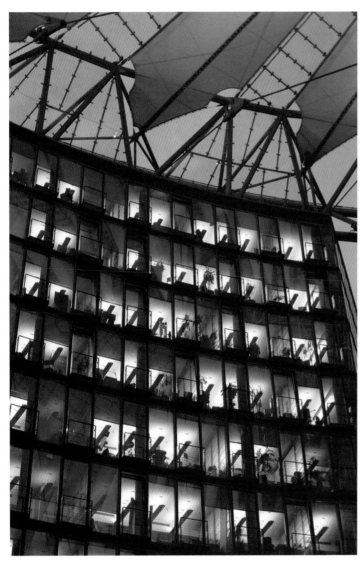

Architecture

Buildings in all their myriad forms are a photographer's
delight and a great challenge too.

We live and work in them so it is easy to take
buildings for granted. To be honest, most of
the buildings we come across in everyday life
are horribly unphotogenic so ignoring them is
a perfectly sensible thing to do.

However, there is no denying that
buildings – old, modern, new or derelict –
offer huge potential to the photographer.
And by buildings, I mean all sorts of

architectural structures from barns and bridges to towers and turrets.

As far as photographic techniques are considered, you are spoilt for choice and it is up to you to choose whichever suits the way that you want to interpret the subject. If that sounds vague, it is. With such a huge variety of subject matter under this broad heading it is difficult to be specific – how

you photograph a glass-fronted office block will be very different from the approach you would take with a derelict barn.

Wide-angle lenses suit buildings because they let you compose with bold foreground and strong lines to bring the viewer into the picture. Point a wide-angle upwards to include the top of the building, however, and you get converging verticals so it looks

Any time of day or night, inside or out, old or new, buildings are wonderful subjects. All three pictures here are 'straight' but show what can be done with careful lens choice. A wide-angle was used for the far left and above shots, while a telephoto was used for the centre image.

like the structure is falling over backwards. It is an effect hated by some and much-loved by others. On page 95, I show how you can quickly correct a mild dose of converging verticals in software.

A tripod might not always be available but hand-holding for sharp shots is possible with long-ish shutter speeds. For this interior shot in Berlin, even setting ISO 800 required a shutter speed of 1/8sec with the lens wide open at f/5.6.

Buildings suit wide-angle lenses and that is one area where digital cameras are less impressive. This is due to the smaller physical dimensions of the camera sensor.

Most of those who use 35mm cameras will understand that a focal length lens of 24mm is a wide-angle. Put the same lens on a digital SLR with its smaller chip and the lens gives an image that looks as if a lens of 35mm or so is used, which is not very wide.

Lens design is catching up, however, and wide-angle lenses are now available that are comparable to the widest lenses of 35mm film cameras. It is worth bearing in mind though that many of these lenses are designed for digital use only and do not project an image big enough to cover the full 35mm film format.

Try a converter

Users of digital compact cameras are potentially even more restricted because of the limited range of the integral zoom lens. That said, lens converters are available that screw onto the front of the fixed lens and give a wider or a longer view. Indeed, if you feel bold try a fisheye converter that will give an extremely wide view. Optical quality of such converters is generally high but do watch out for flare and contrast problems when shooting against the light.

Wide-angles are my lenses of choice when it comes to buildings but there is much that can be done with telephoto optics too.

Shooting from afar means there are no converging verticals to contend with, plus there is an effect called telephoto compression to enjoy. This is sometimes called 'stacking' and is basically a perspective fore-shortening effect so

Changing ISO

Digital cameras let you alter ISO sensitivity at will, which is a huge advantage compared with film cameras. The lowest setting on a digital camera is usually the best and sensitivity is boosted to give effectively higher ISO settings. Some cameras are more susceptible to 'noise' than others and this is a facet of your camera's performance that is worth testing if you have not yet experimented with different ISO speeds.

For my test, I choose to shoot the floodlit Fotheringhay Church one evening. The camera was set to its RAW picture quality mode, mounted on a tripod and a remote release used to trigger the shutter.

A 20-35mm wide-angle zoom was used and the camera kept upright to avoid converging verticals.

ISO 100

Comment: The best, full of tone and no noise despite the lengthy shutter speed. Very smooth rendition of details. **Exposure:** 8seconds at f/8

ISO 200

Comment: Peer closely and you can see noise and colours seem less rich but image quality still very high. **Exposure:** 4seconds at f/8

ISO 400

Comment: Definite signs of noise but image is still sharp with ample detail on show. **Exposure:** 2seconds at f/8

ISO 800

Comment: Fine details now starting to be lost with plenty of noise breaking up the image. **Exposure:** 1second at f/8

ISO 1600

Comment: Detail and sharpness now suffering quite poorly and there is an obvious 'grainy' look. **Exposure:** 1/2secat f/8

ISO 3200

Comment: Hot pixels and noise aplenty. Only use this sensitivity when desperate or you want the pointillist effect. **Exposure:** 1/4sec at f/8

Look for structures that work as lead-in lines in pictures and use a wide-angle lens to make the most of them.

buildings look much closer to each other than they are in reality. This effect can look great pictorially with the right camera viewpoint and subject.

Buildings definitely benefit from good lighting. In fact, as far as this subject is concerned, there is nothing worse than a dull day with a grey, overcast sky.

Favourable conditions, ie directional sunlight and a blue sky, are well worth waiting for if you are doing a daylight shoot. An attractive sky makes for an excellent background and this can be intensified further with a polariser filter. This filter is incredibly useful for buildings because it can cut down on reflections off mirrored glass surfaces as well as enrich a weak blue sky. However, do use polarisers with care. A vivid sky can be over-polarised and what

should be a welcoming blue can go almost black and metallic-looking. Neither effect will ultimately look pleasant.

Another nasty side-effect of the polariser occurs when used with a wide-angle lens, because light from different parts of the sky is polarised to different degrees. The polarising effect is strongest at right angles to the sun and because of the wide view there is an unnatural patchiness. In this instance, taking the polariser off completely is the best advice.

A question of timing

My favourite time for buildings is within an hour of the sun going down. There is still colour in the sky, the building is artificially lit from inside as well as outside and car lights start becoming a factor.

A tripod is essential, which means you can shoot at medium ISO speeds for quality.

Using higher ISO speeds results in an increase in 'noise' while with very long exposures, say in excess of ten seconds, digital cameras suffer from 'hot' pixels.

A hot pixel can appear white, red or green and the longer the exposure the more visible the hot pixels.

Many SLR digital cameras have software to reduce the effect of noise caused by setting a higher ISO, although using it does slow down the write speed to the storage card.

Curing 'stuck' or hot pixels is best done by the 'dark frame' technique, which involves taking another shot of the scene with the same settings but with the lens covered up.

All in all, especially given the drama possible at night, the effort of taking a tripod out is worthwhile and you will certainly get images with a difference.

I often use people as focal points in my compositions. They add an important sense of scale but also an element of intrigue, especially if they are not clearly recognisable, as here where a shutter speed of 1/6sec has blurred the figures.

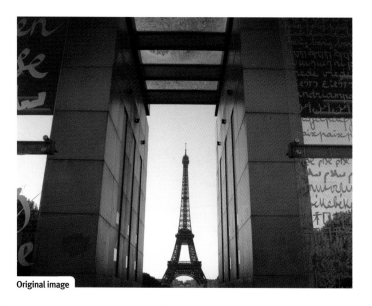

Original image

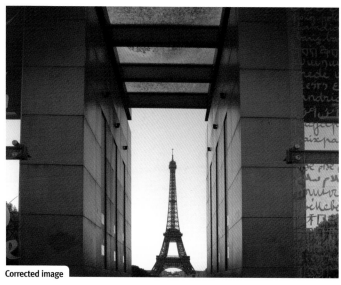

Corrected image

Correcting converging verticals

If you prefer your buildings standing correct and upright, it is easy to do.

Step 1

PREPARATION Open the image and give yourself more room to work by clicking on the bottom right corner and pulling down to enlarge the canvas.

Step 2

NOW CORRECT Select all by going to Select>All or using Ctrl A to bring up the marching ants around the picture. Now go to Edit→Transform→Distort.

Step 3

FINAL STEP Now pull the top right and top left handles to change the image's shape. Adjust until you're happy, then press Enter to confirm the transformation. Deselect with Ctrl + D. ■

The world in black & white

The world's a richly coloured place but there are many photographers (myself included) who prefer it black, white and delicate shades of grey.

There is nothing to rival the richness of a beautifully crafted monochrome photograph. Traditional – and by that I mean chemical – black & white photography allows complete user-control, particularly for those photographers with access to a darkroom. From film developer and paper choice to grade selection and toning, there is no doubt that if you enjoy rolling up your sleeves and getting stuck in there is little that compares to working in a darkroom.

That said, this avenue of pleasure is not open to all nor, indeed, does it appeal to everyone, so the chance to really enjoy and take control of the medium is limited. Digital means that everyone can get involved.

Personally, I love having the convenience and unlimited creative potential of digital while my chemical darkroom remains well-stocked and regularly used. For me, there is simply no greater thrill than seeing an image emerging in the developer.

Molly was photographed by windowlight late one afternoon. I liked the colour version but I felt more mood would be injected by turning it mono. This I did using the Channel Mixer in Photoshop 7.0/CS, a technique that is explained on page 100.

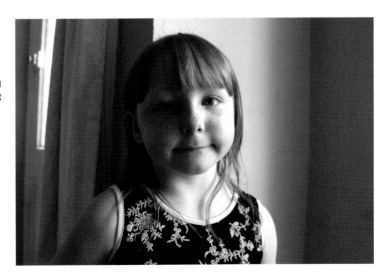

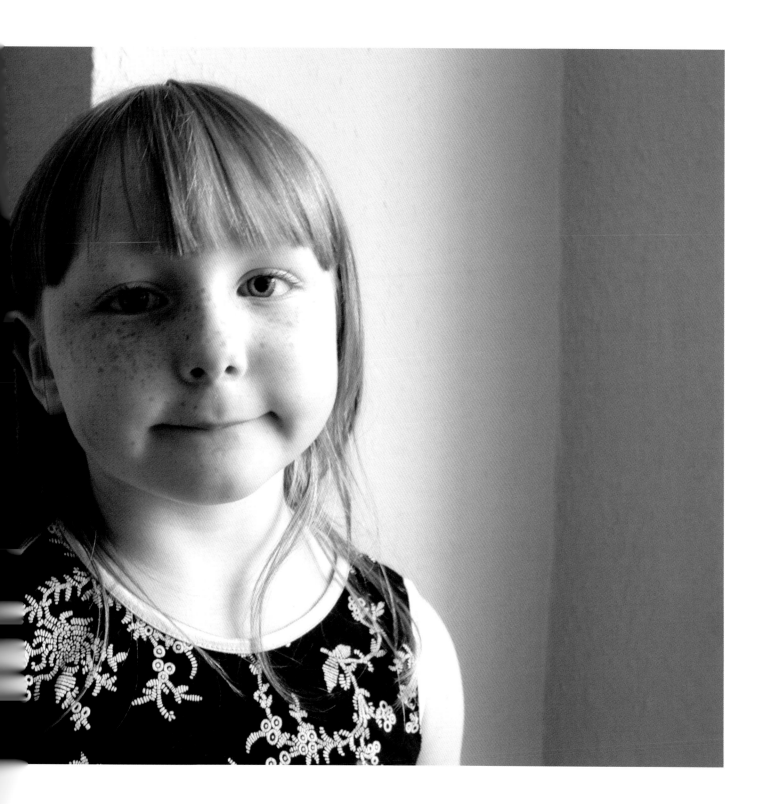

Of course, where digital really wins is when a photographer does not have to go out with two film types, colour and mono, or have two camera bodies.

Now it is perfectly feasible to take every picture in colour and to think about the aesthetics later. But there is a minor flaw in this retrospective approach. I believe that to get the most from black & white you need to be thinking in terms of shades of grey, tonal contrasts and textures at the time of taking the picture. The black & white photographer is looking for different things within a scene compared with a colour worker, which explains why I prefer to use a black & white film in the first place. Knowing that I am shooting mono forces me to think in shades of grey, rather than seeing everything in full colour. It is a discipline thing.

Another reason why I do this is the fact that I like to have an original black & white negative. This I can print traditionally in the darkroom should I prefer but obviously I can also scan it in and work on the image on the computer. Being creative with how images are outputted or shown is obviously a massive point in favour of digital. It is, in my view, enjoying the best of both worlds.

One more factor in preferring to work like this is that while digital does give fine black & white prints, I prefer the ultimate quality possible with the chemical process. Traditional prints have a depth and luminousity that is not there with inkjet prints – at least, not yet. The manufacturers of scanners, printers, inks and media still have progress to make in this field before I consign my darkroom to the loft. But I guess it will just be a matter of time.

Making great mono inkjet prints

Most inkjet printers only have one well of black ink. This is fine for colour printing but it is a drawback when it comes to mono output.

Imagine, with this single black ink you are expecting to make prints that exhibit a full range of mono tones, from the richest black to the most delicate of subtle greys. Clearly, prints produced in this way are not going to exhibit the superb and smooth tonality of a chemical print, which is why inkjet mono prints can look harsh.

With a standard inkjet printer, the best mono prints are produced when the colour and black inks are used. You will need to make some tests to get prints free of unacceptable colour casts.

The general short-comings of mono inkjet print making has got the research people working overtime, and now printers, papers and inks are coming out that are better equipped to deal with the demands of high quality black & white printing.

For example, special inksets that have two, four and even six hues or 'colours' of black ink are available, designed to deliver a smooth range of grey tones and print hues.

Of course, if the aim is to

make the highest quality mono prints on a regular basis, an inkjet printer dedicated to using these special inksets is recommended. It is simply not practical to constantly switch from colour inks to black inks as the demand arises.

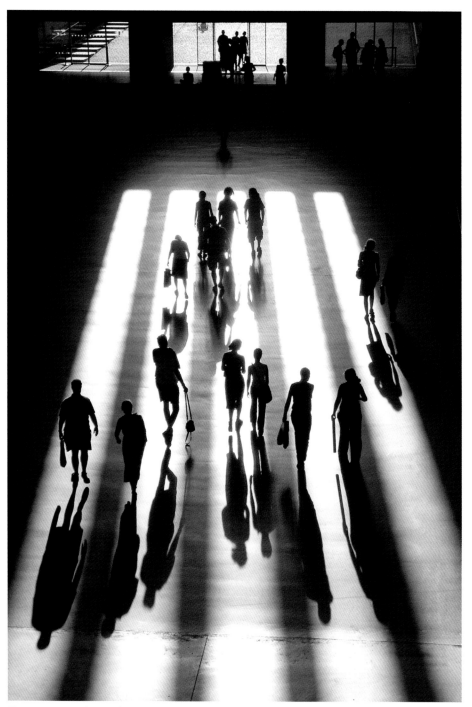

Many scenes are much more effective in black & white than in colour. You may or may not appreciate this at time of taking the shot, but digital gives the option of exploring both before deciding.

Which mono film scans best?

If, like me, the idea of shooting mono film to get the most of the digital and chemical processes has appeal, then you want to know which film is best to use. I would go along with that but you will not be surprised to learnt that life is not that straightforward.

There are so many variables in mono film photography. How a film is rated and exposed, the developer, the processing time and the scanner itself will all have an impact on the result.

Generally, it is best to stick with medium speed films that are exposed normally and processed in a soft-working, fine grain developer. You need as much detail in both the shadows and the highlights as possible, which means low to medium contrast negatives but not too flat.

Chromogenic black & white films, which are processed in C41 chemistry and use dyes rather than silver, offers another option. This film type does scan well using the scanner's colour negative setting.

Convert colour to mono

Photoshop offers several ways to convert colour images to glorious black & white

The creative option of converting colour originals to black & white is well worth exploring and the results can be excellent. How to get to mono from colour, however, is another thing because there are several methods, all of which work but some are more effective than others. I have played with all the methods and personally, I prefer using the Channel Mixer in Photoshop which allows intricate tonal control. Other photographers use LAB Color mode in Photoshop while others prefer the speed of simply converting to grayscale or going the desaturation route. Try the methods outlined here before making up your mind.

The methods described here relate to Adobe Photoshop 7.0/CS, and other softwares, such as Paint Shop Pro and Elements, will work differently. More basic softwares might not have so many options so do check with the instruction manual.

Using Channel Mixer

■ **This is arguably the best method and gives excellent black & white images with great controllability.**

Go to Image→Adjustments→ Channel Mixer to call up the menu and click on the Monochrome box. Now just adjust the Red, Green, Blue sliders until you get a good effect. Usually, it is a combination of the Red and Blue channels that work best. The ideal is to get the percentages to add up to 100%.

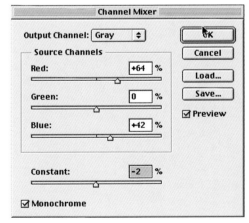

Colour original

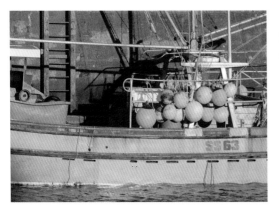

Using LAB Color

■ **This is a very effective way of converting to mono in Photoshop 7.0.**
Go to Image→Mode→Lab Color. In the Channels palette there are four options. Clicking on Lightness gives a mono image and adjust Curves or Levels to alter contrast.

Desaturate

■ **A simple way of changing colour images to black & white.**
Go to Image→Adjustments→ Desaturate. It works well but other methods give better results.

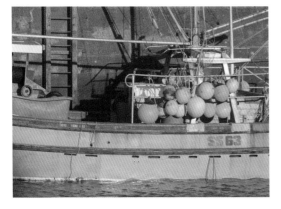

Going grayscale

■ **This the simplest, but probably the least effective, way of converting images to mono.**
Go to Image→Mode→Grayscale, then do any Levels adjustments as needed.

Using Channels

Call up the Channels palette by going to Window→Channels. Click on the Red, Green or Blue channel to see the effect, which is similar to when a contrast filter is used on the camera. Go to Image→ Mode→Grayscale to finish.

Red channel

Green channel

Blue channel

4 Digital techniques

Creating a digital workflow

You will enjoy your digital imaging more if you use a methodical workflow. It will guarantee your sanity too!

The journey from making an exposure on the digital camera to the final print is a logical process and all along the way there is the opportunity to create and invent. The digital image workflow is more involved than film with potentially an infinite number of twists and turns that have to be negotiated.

The realisation that I needed a logical working procedure came early on in my digital shooting career. Even after a few months, my computer's hard drive was cluttered with a seemingly random selection of folders containing a selection of very similar images at different stages of completion. I ended up working on the wrong files or deleting the ones I had worked on. In short, I did not have a clue what was going on.

Quite frankly, I was in a mess and that was when I realised I needed the discipline of a structured workflow and what follows is broadly that. It is important to stress that the outlined process is very personal and I make no claims about its efficiency or effectiveness, nor am I suggesting that you follow it religiously. You might prefer a more simple process or, indeed, you might not find it sophisticated enough.

Over the next following pages I delve into the relevant core image editing techniques in more detail.

1 Camera set-up

I used to shoot fine quality JPEGs and was perfectly happy. JPEGs are quick to write to card, give greater shooting capacity and can be opened with any image editing software. Now I shoot RAW files, which are slow to write to card, give limited shooting capacity and can only be opened in RAW-compatible software. It sounds like I have taken a massive step backwards and in some ways I have. What I do know, however, is that there are benefits, namely superior image quality and greater controllability during RAW processing. I now shoot RAWs most of the time. I only switch to JPEG for snaps, 'notebook' images or when I want to shoot lots of images quickly, something that RAW would be too slow to handle.

I have my Canon EOS 10D's white balance set to auto, knowing I can change this during RAW conversion, and usually expose everything in aperture-priority automatic exposure mode.

2 In-camera editing

The obvious failures are deleted or 'chimped' as soon as possible. Deleting failures at this stage maximises storage space and saves processing time later. Duff exposures, dreadful compositions and images suffering from shake or movement are deleted.

3 Download images

At home, images – both crw and htm files – are downloaded to the computer using a FireWire card reader. Downloading with a USB2.0 or FireWire card reader is fast.

Images are put in folders marked with the date, event and location. Having the camera set to continuous numbering and the correct date and time helps keep order.

If I am away from home, I take my Innoplus PhotoTainer digital album and download images into this. This has a capacity of 40GB and when I get back to base, it is hooked up to the computer and it shows up as another hard drive. The images are transferred over as normal.

4 Archive RAWs

With the original RAWs, before doing any work, I make a copy of the images onto an external hard drive. I use the files on the hard drive to work from. Another set of copies is burnt onto CD or DVD for my archive. These discs, once verified, are put straight into storage.

5 Check out the images

The RAW converter of Photoshop CS comes in very useful here and images can be checked before conversion to TIF or JPEG. An alternative to use is Extensis Portfolio 6.1.2 with a RAW plug-in.

6 Convert RAW files

RAWs are digital negatives, and just like their film equivalent, need careful processing to ensure the best possible result.

Rarely do I convert every image, so I prioritise those images that I intend printing and convert the RAWs to 16-bit TIF files.

I started with Canon's File Viewing Utility that came with the camera to convert RAWs to TIFs but found it slow and explored the third party option. Photoshop CS's RAW conversion skills are very good and there is plenty of control available within this facility.

7 Once converted

Photoshop 7.0 has limited compatibility with 16-bit files but that is not the case with CS. I keep the best pictures as 16-bit, but for images that I want to keep but not print up to A3 I switch mode to 8-bit (Image→Mode→ 8-bits/Channel), which halves the file size.

8 Crop the image

Cropping should not be rushed, and care must be taken to ensure that you retain good composition. By cutting out unwanted sections of the picture, however, you save yourself working on parts of the image that you may not want later. There is more on cropping on page 110.

9 Adjust Levels

Time to sort image density and, even if the camera exposure is spot-on, the Levels usually need a tweak. I move the black arrow to where the blacks begin, the highlight arrow to where the highlights start and adjust the grey arrow until I get the desired density.

10 Colour balance

I like my pictures on the warm side so I add a few units of extra red or magenta and/or take out some blue. This all depends on the individual image. See page 116 for more on colour balance.

11 Clean up image

Regular cleaning of the digital SLR chip is advised but even this will not guarantee pristine images, so you might need to clean up the picture. I use either the Clone Stamp Tool or the Healing Brush Tool to do this, depending on the individual circumstances. See page 118 for more on cloning.

12 Save

With images that involve a great deal of work, I save after each major stage in case of a computer crash. I save in either LZW-compressed TIFs or Photoshop PSD if I want to keep any layers for future work.

13 Write to disk

I would have been backing up work in progress onto my external hard drive, but now, with all the hard work done, it is time to burn copies onto CD/DVD. Of course, for most images this is the end of the road, but a select few will make it into print.

14 Resample

My usual style of presentation on a sheet of A3 paper is placing an image measuring 38cm across at the centre with a broad white border. With a Canon RAW file an image measuring 38cm gives an image with a resolution of 205ppi.

15 Add a border

For good presentation, I prefer a thin black border using the Stroke (Edit>Stroke) command. It take a few seconds and gives that extra bit of class. See page 140.

Get organised!

Keeping organised is important. I use a set of folders and move pictures through the various folders as work progresses. After a shoot, images are downloaded into Folder 1. Original RAW files are like digital negatives and I always make back-up CD/DVDs of the image files in this folder. The files are then moved through the series of folders.

16 Unsharp Mask

The final step before making a print is adding an Unsharp Mask (USM), Filter→ Sharpen→Unsharp Mask. The thing is to avoid over-sharpening an image, a common mistake. Over-sharpening gives artifacting and the picture looks harsh and gritty.

17 Make a print

Admiring the final, perfect A3 print makes all the effort that went into the image thoroughly worthwhile.

The process from initial download to clicking the print button is not as time-consuming as it might sound, and five-ten minutes per image is typical

Making perfect scans

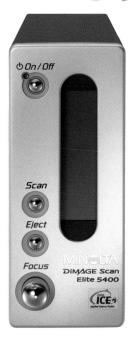

Your film originals are packed with information and good scanning technique means you make the most of your images.

The first thing to consider before making a scan is deciding what you want the scan for. If an image is destined only for posting on a website there is no point making a large, high resolution scan. Flatbed scanners are generally more user-friendly than film models in this respect. On many models all you have to do is push the appropriate button for scans destined for a specific purpose.

If you have a library of slides and negatives most of your scanning will be for archive purposes, so the aim is to get the highest possible quality scans possible.

I always start by giving the image to be scanned a blast with a compressed air cleaner followed by a careful wipe with a blower brush. This disposes of most of the surface debris and I do this even though my scanner has ICE cleaning software.

ICE software is designed to remove any dust but some photographers prefer not to use any processing software because of the possible compromise in ultimate image quality. However, according to my tests with and without any cleaning software I found that any quality differences are minor relative to the huge amount of time saved cloning and retouching.

A prescan is well worth making, and most scanners let you make and preview a wide variety of corrections before going for the full scan.

I always use the prescan facility to assess what image corrections are needed. Most scanners have a basic mode but in the advanced interface you can adjust colour balance, contrast, cropping, saturation and much more as you see fit.

Take control if necessary

Focusing and exposure should be carefully checked along with your other corrections. Scanners are autofocus and autoexposure but do not take it for granted that they will work perfectly. Some images can cause problems, especially regarding focusing, and if this is the case switch to manual focusing.

There is a school of thought that says any adjustments and tweaks are best made in the image-editing software. However, I feel it is commonsense to get as much quality information off the film during scanning as possible. More advanced scanners give the option of 16-bit operation as well as multiple pass scanning for the best quality.

You might not get it right first time so once any adjustments have been made it is worth doing another preview to check their impact. Once you are happy with the preview, go ahead with the full scan.

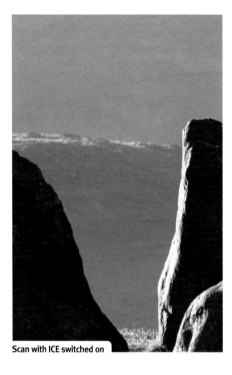
Scan without ICE

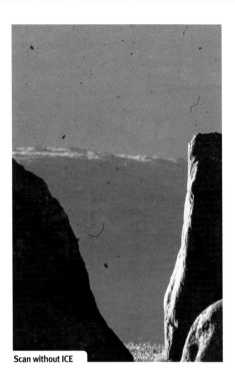
Scan with ICE switched on

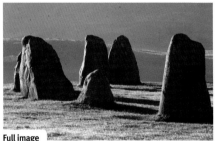
Full image

ICE in action

Some scanners have image cleaning software which automatically helps to eliminate dust and hairs. The pair of scans above from a Minolta Dimage 5400 scanner shows the effect of the ICE (Image Correction and Enhancement) software.

Scanner resolution explained

Two figures are usually quoted for scanner resolution, such as 1200x2400ppi. The first is the all-important optical resolution figure and tells you how many sensors there are per inch across the width of the scanner's head. Some makers quote interpolated or enhanced resolution figures but these are misleading. Look for the true optical resolution figure. The second, higher figure is the mechanical resolution, ie the maximum number of 'steps' a scanner takes as it traverses the length of the image.

Cropping

Pictures can be improved quickly and effectively by cutting out some of the clutter or even changing the shape.

Let me say right now that the most effective cropping you can do is at the time of taking the picture. Zooming in closer, trying upright and horizontal formats or taking a few steps to one side can all improve composition instantly and with minimal effort.

In a perfect world we would all get brilliant compositions at the first time of asking but sadly that is not the case and cropping afterwards should be considered a fact of life.

Cropping in software is easy and there is the time to contemplate and try out a variety of ideas at no risk to the original.

This picture was taken at the Venice Carnival. It was very busy and hordes of photographers were jostling for the best camera viewpoint. With so much going on there was actually very limited time to try different compositions. It was difficult enough to get a half-decent picture.

I was shooting with a 70-200mm telezoom used at maximum aperture on my Canon EOS 10D and I managed a tightly framed picture with a nicely blurred background. But I was not happy with the shape of the picture and reckoned that its impact could be improved with cropping, so I had a play with various options.

Tips for using the Crop Tool

Pressing the C key is the quick way to select the Crop Tool.

STRAIGHT CROP
Start at the top left, click and hold the mouse and draw out the mask. Release the mouse button and a frame of 'marching ants' shows the extent of the crop. The crop can be adjusted. Click the pointer inside the area of marching ants and hold the mouse button down at the same time and you can move the cropped area around. The crop can be altered by clicking on one of the handles in the frame and dragging it out to suit.

ROTATE THE CROP
The crop can also be rotated around the central point. Place the cursor outside the masked area and a pair of bent arrows appears. Click the mouse and you can rotate the crop. If you do not like the crop at any time, press the esc key and start again.

COLOUR THE SHIELD
You will notice that when the Crop Tool is in use the menu bar itself has more options. Tick the Shield box and the cropped area is masked off and you can colour this and change its opacity.

SET THE CROP
The crop size and the resolution of the crop can be set using the Crop Tool bar. Clicking on Clear removes the settings. These settings can also be stored for future use and there are presets too.

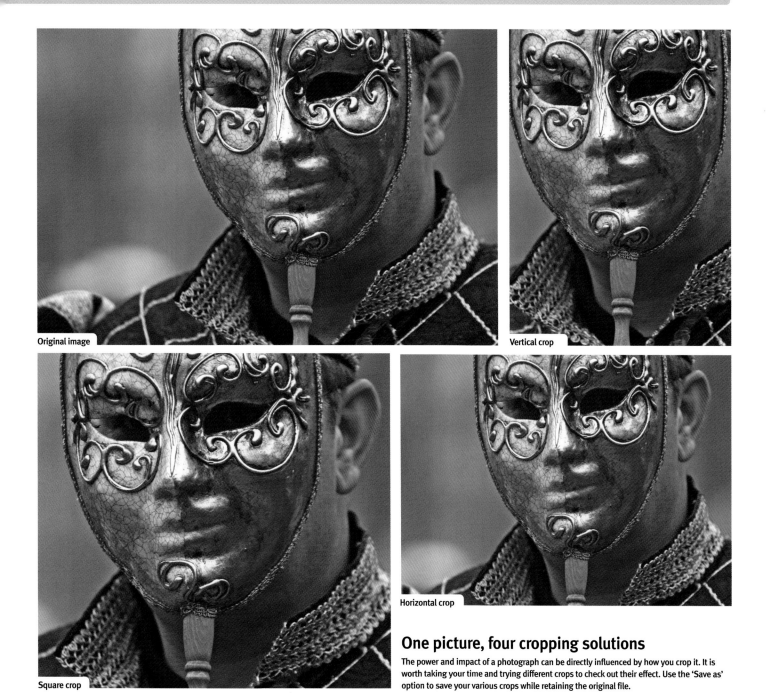

Original image

Vertical crop

Square crop

Horizontal crop

One picture, four cropping solutions

The power and impact of a photograph can be directly influenced by how you crop it. It is worth taking your time and trying different crops to check out their effect. Use the 'Save as' option to save your various crops while retaining the original file.

Levels

Open a digital image file and you are almost guaranteed that its contrast and exposure will need a tweak in Levels for the best possible result.

Adjusting Levels is a simple editing technique method to understand and makes a huge difference to an image. Photoshop/Elements offers an Auto Levels function but this is best avoided. It can also produce a contrasty result complete with a colour cast.

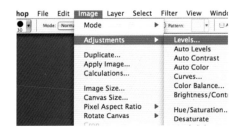

The best advice is to manually adjust Levels. Using the many features of Levels can correct exposure and contrast as well as eliminate or induce colour casts.

Where to find Levels

■ **Photoshop 7.0/CS**
Image→Adjustments→Levels, shortcut Ctrl + L
■ **Elements 2.0**
Enhance→Adjust Brightness/Contrast→Levels, shortcut Ctrl + L
■ **Paint Shop Pro 8.0**
Adjust→Brightness and Contrast→Levels or Histogram Adjustment, shortcut Ctrl +Shift+H

All about the Layers palette

Call up the Levels menu and you get a graphic interpretation (a histogram) of image's tonal range.

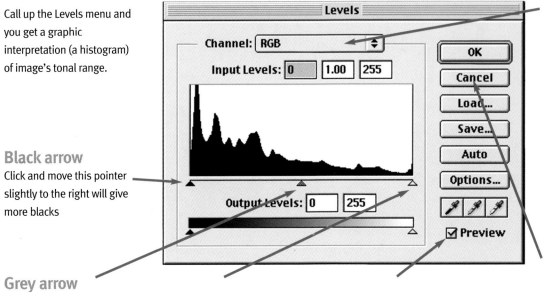

Channel
RGB is the default setting. Click on it and you can adjust each individual channel.

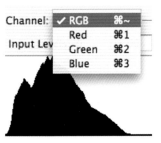

Black arrow
Click and move this pointer slightly to the right will give more blacks

Grey arrow
Moving this adjusts the grey point and effectively varies the exposure

White arrow
Click and move this to the left to give more white tones

Preview
Make sure this is ticked so you get a preview of any changes

Cancel button
Click to cancel but push Alt at the same time and a Revert to the original image option is available.

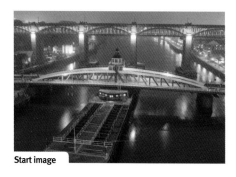
Start image

Step-by-step

The usual advice with the Levels control is click on and pull the black and the white arrows to where the graph profile starts. That is fine, but another way is to use the pen droppers, as I did for this night picture taken in Newcastle-upon-Tyne.

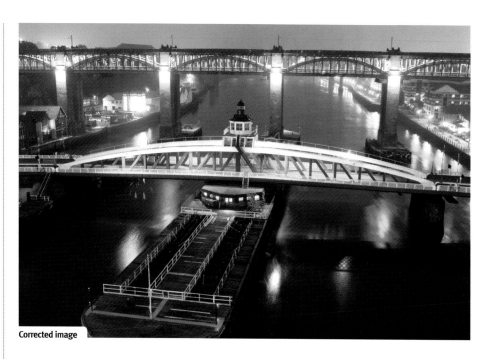
Corrected image

Step 1 Black point

Let us start with the black dropper. Select it and move the mouse cursor around and rest it on an area that you want to come out black. I went for the shadows under the bridge. Click once and you will see a change.

Step 2 White point

Now to the white point. Again click on it to make it active and move the mouse to place the cursor over an appropriate spot. The white section of the swing bridge was an obvious spot. Click and you can see how the whole image is much brighter.

Step 3 Finished print

Once you are happy, click OK. If you are unhappy with the look, press Alt and you will notice the Cancel button change to Reset. Click on this and the image will revert to its original condition and you can try again.

Curves

Using Levels is a great and effective way of controlling contrast, but Photoshop's Curves function adds another dimension.

Many photographers use Levels to adjust contrast and exposure, but in the various full versions of Photoshop there is the option of Curves. It is not available on Elements 2.0.

It is true that Curves is not as fast to use or as easy to understand as Levels. Call up the Curves menu and you will be presented with a graph that features a straight line running at a diagonal of 45 degrees.

You can achieve some really outlandish and extreme contrast effects with Curves by clicking and changing parts of the line. Generally, however, all you need to know is

the power of the 'S' curve. Use it carefully and you can darken down the dark greys and brighten the light greys without affecting the deep blacks, mid-greys or brilliant whites. Doing this increases contrast without losing any delicate highlight or shadow details.

Where to find Curves
Photoshop 7.0/CS
Image→Adjustments→Curves, shortcut Ctrl + M
Paint Shop Pro 8.0
Adjust→Brightness and Contrast→Curves

All about the Curves palette

Curves window
The box with its diagonal line is the key feature of Curves. Change the shape of this line and the whole nature of the image changes. To alter the line, simply click on it and move the mouse.

Black and white scales
The vertical axis shows the new brightness levels of an image after correction while the horizontal axis represents the original levels. If you prefer, Alt+click changes the 4x4 grid to a 10x10 grid.

Input and output levels
Hover with the cursor on the graph itself and you will see two figures. Input is the original levels (0 is black, 255 is pure white) value of where the cursor is resting and the output value is the value when the curve is adjusted.

Channel selector
Click on this to pick a specific colour channel to work in. Use this to vary the image's colour.

Curve mode
The default mode is the one to use for subtle, controlled contrast adjustments.

Cancel
Takes you out of the Curves interface. Press the Alt key and the Cancel button becomes a Reset button.

Auto/Options
Click this if you want Photoshop to adjust Curves on your behalf. Generally, it is best to leave this alone and adjust curves manually. Options gives more advanced control over the Auto Curves function.

Eyedroppers
From left to right, black, grey and white. Select the black dropper and place the cursor over an area you want to come out perfect black and click the mouse. Do the same with the white dropper for a pure white tone. The diagonal line does not change during this process and it can be adjusted afterwards.

Start image

Step-by-step

Opening this backlit image taken on a Nikon D100 revealed a flat image that needed help from Curves. I used a basic S curve. The more extreme the 'S' the harsher the contrast and such effects are best avoided in your pictures unless you want graphic results.

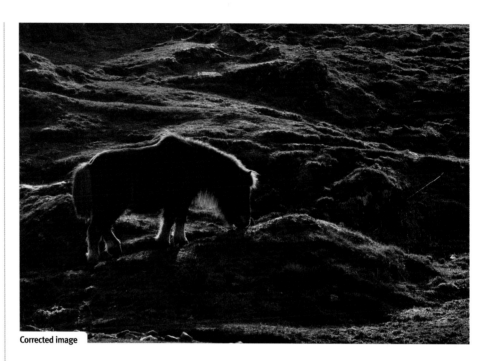
Corrected image

Step 1 Open the image
Open the image and the Curves menu shows a straight line running diagonally upwards at 45 degrees. This can now be altered.

Step 2 Start with the shadows
To start making an 'S' curve, simply click on the diagonal line where it intercepts the vertical line and drag it down slightly. This enhances the shadow details.

Step 3 Curves highlights
At the top quarter of the graph, drag the line upwards by the same amount to brighten the whole image. Once you are happy, click OK to confirm the Curves adjustment.

Perfect colour made easy

The mood and impact of a picture is hugely influenced by its colour balance. Therefore, learning how to adjust colour is a technique worth developing.

Image editing software usually offers more than one way of achieving a particular effect, and that is certainly true when it comes to adjusting colour balance.

In Photoshop there is a Color Balance menu, but this is probably not the most effective tool for correcting colour. Levels or Curves can be more useful and another option is Variations. With the amount of control possible, the Variations menu is effectively identical to the Color Balance menu but it is easier to use because there is a visual check. In Levels and Curves you can adjust the individual colour channels to alter an image's colour balance.

Where to find the Color Balance palette
Photoshop 7.0/CS
Image→Adjustments→Color Balance or shortcut Ctrl + B
Image→Adjustments→Variations
Photoshop Elements 2.0
Enhance→Adjust Color→Color Variations
Paint Shop Pro 8.0
Adjust→Color Balance→Color Balance

All about the Color Balance palette

This is the Color Balance menu in Photoshop 7.0/CS

Watch the figures
These figures change as the colour balance sliders are moved so accurate changes are possible.

Image density
Have the Preserve Luminosity box ticked so any colour changes you make do not affect image density.

Control sliders
Click and pull these sliders to adjust colour balance. Moving the pointer towards the colour name will increase the strength of that colour.

Cancel or Reset
Click on cancel to exit from Color Balance or push Alt and this becomes a Reset button.

See a preview
Have the Preview box ticked and you can see the effect of any changes you make.

Pick a tone
Click on which aspect of the image's tonal range you want to adjust.

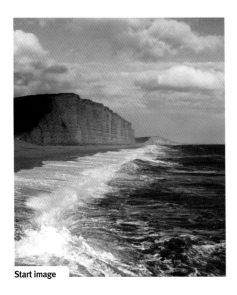
Start image

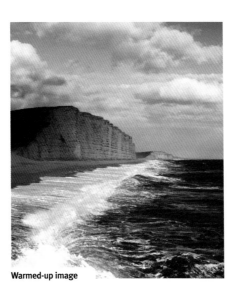
Warmed-up image

Step-by-step

It was early evening when I took this coastal landscape and the light was attractively warm. When I opened the image in Photoshop, I felt that the scene did not look warm enough and needed the help of the Color Balance menu to enhance the effect.

Step 1

The Color Balance menu is brought up using Ctrl + B. I started with the Midtones by adding 20 more units of Yellow and Red.

Step 2

More Yellow and Red were added with the Shadows option selected.

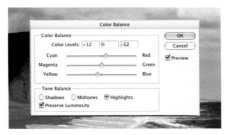

Step 3

Finally, it was the turn of the Highlights and the same colours were adjusted.

Variations

The Color Variations menu in Photoshop is a great way of tweaking colour balance.

■ **TONAL VALUES** Click on which aspect of the image's tonality you want to adjust.

■ **FINE/COARSE** For subtle variations move the slider towards Fine; for more obvious changes move the slider towards Coarse.

■ **SHOW CLIPPING** Tick this and any channel clipping will be shown.

■ **ORIGINAL AND CURRENT PICK** This pair of images shows the original and the state of the currently adjusted image. Clicking on the original takes you back to the beginning.

■ **CANCEL BUTTON** Click this to cancel but if the Alt key is pushed Cancel changes to Reset.

■ **COLOURS** Click on each image increases, or decreases, that colour. Adjust until you have the effect you want, then press OK.

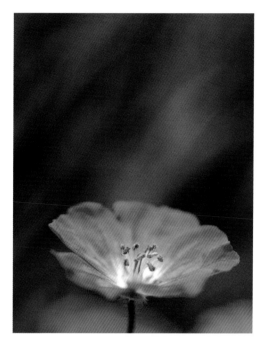

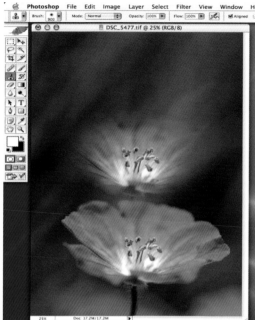

Clone it

Cloning is an essential image-editing technique and vital in a great many situations. There is no doubt that every photographer should learn the basics.

The Clone Stamp Tool works by sampling pixels from one area of the image and painting or repeating them in another. You can even paint them to another image.

The most common use for the tool is for cleaning or repairing flawed images. It might be a scan of a damaged print, an image from a dirty camera sensor or the removal of distracting elements within a composition.

All in all, it is a powerful and useful tool and fairly easy to use, even for the novice.

The first step in successful cloning is selecting an area to sample from. This is called the source point. To sample from your chosen area, hold down the Alt key and a target appears and you left-click to sample.

Release the Alt key and each time you left-click the sampled pixels will be painted onto the image. A small cross shows the area you are sampling from and, with the align box ticked, this cross will follow the brush as you move around the image.

The brush's size can be varied by using the square bracket ([and]) keys, the left key for decreasing and the right for increasing. How the brush is shown on screen can be varied in Photoshop's Preferences.

Cloning options

Select the Clone Tool, shortcut key S, and you will see a number of parameters in the options bar that you need to consider before you start cloning.

Opacity

Control the density of clone by adjusting the opacity slider. For most cloning purposes, leave Opacity set to 100%. Set a lower figure when you want a more subtle effect or where there are smooth mid-tones.

Mode

The default blend mode is Normal and this is fine for standard cloning tasks but many modes are provided for different effects so do experiment with them.

Aligned

Tick the Aligned box and the area sampled by the Clone Tool is kept at a constant angle and distance from the point where you paint. Uncheck the Aligned box and the source point

remains fixed so that you are able to repeat the same pixels when painting.

Brush

There are many preset brush types available and you can make your own custom brushes too. You need a brush that suits the size of the image and task.

Healing power

The Healing Brush Tool was one of the most exciting tool innovations in Photoshop 7.0. It makes seamless image retouching very easy indeed.

The Healing Brush Tool is incredibly useful and makes the perfect retouching and repair of demanding images very simple indeed.

It works like the Clone Stamp Tool because you have to sample first by using the Alt key and mouse clicking on an area of pixels before painting over the destination area.

But the Healing Brush does not just simply deposit the sampled pixels over the destination area. Instead, the software actually assesses the destination area and blends in the sampled pixels for a seamless result. This is why when you release the mouse during painting that there is a time

delay of a second or two while the software does its 'healing'.

The Patch Tool

Select the Healing Brush Tool (shortcut key J) and you get other options, the Patch and the Color Replacement Tools. The Healing Brush Tool is the most useful in photography.

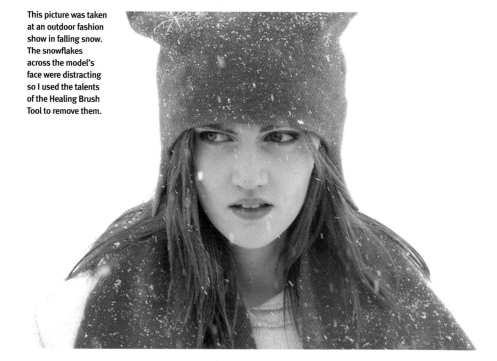

This picture was taken at an outdoor fashion show in falling snow. The snowflakes across the model's face were distracting so I used the talents of the Healing Brush Tool to remove them.

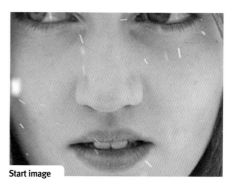

Start image

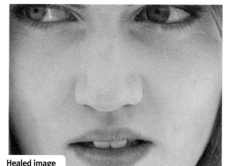

Healed image

All about the Healing Brush Tool Palette

Mode setting
The effect mode is similar to blending modes and defines how the Healing Brush will work depending on the source and the destination pixels. Normal mode is the default setting. The other modes can be tricky to predict so just try them with different images.

Sampling mode
The normal mode is Sampled where you sample pixels to be used from the area you are working on. Select Pattern and the Healing Brush will try to blend a selected pattern with the existing image.

Where to sample
The default setting is unaligned so this tick box is empty. Tick the Aligned box and the area sampled by the Healing Brush Tool is kept at a constant angle and distance from the point where you paint.

Pick a brush
You can make your own brushes to suit your preferred way of working and the effect you require. These can be stored as presets for future use. Brush size, hardness, shape and spacing of successive strokes can be altered.

Tips for the Healing Brush

■ A hard-edged brush allows more control than a soft-edged brush.

■ It is usually best to keep sampling and dabbing over the area to be repaired, rather than going for one larger stroke.

■ Let the computer finish working after each painting stroke and examine the effect first before moving on.

■ Use Ctrl+Z to go back one step.

■ Use the Clone Stamp Tool to smooth out any edges after healing.

Image resizing

When you open an image file you will usually find that you will have to resize it to suit a particular purpose and that is why you need to know about something called interpolation.

Where to find Image Size

Photoshop 7.0/CS
Image→Image Size

Photoshop Elements 2.0
Image→Resize→Image Size

Paint Shop Pro 8.0
Image→Resize, shortcut keys Ctrl+S

Changing the dimensions of an image is achieved using the Image Size dialogue menu. Open this and you will see that the default setting of the dialogue box has the Resample Image box ticked. This means you can enter new pixel dimension figures to increase or decrease image size. In practice, it is more likely that you will change the image's physical dimensions by using the Document Size boxes and then setting the desired resolution. For instance, if you want photographic quality prints the resolution figure of 300pixels/inch should be entered.

With the Resample Image box ticked, when the image is decreased or increased in size the number of pixels has to be decreased or increased accordingly. Assessing the values for any new pixels is done within the editing software with a resampling process called interpolation.

What happens is that Photoshop will look at the neighboring pixels to calculate the values needed for new pixels. In short, the software will make a very highly educated guess for the new pixel values. Obviously, there is a risk to ultimate quality but this can be surprisingly small.

Methods of sampling

There are three basic methods of interpolation: Nearest Neighbor, Bilinear and Bicubic.

Nearest Neighbor is the simplest, fastest but least precise interpolation method while Bilinear interpolation gives better quality but only reads the horizontal and vertical neighboring pixels. Bicubic

Full image

The original digital camera image opens up to an 18MB file and, according to the Image Resize dialogue, showed that it could produce a 10x7in print at 300ppi. Using Photoshop's Bicubic interpolation to resize the image to a 30x21inch print at the same resolution produced a file of 162MB. The interpolated image is of a high standard and certainly good enough at a normal viewing distance.

Quality of image at 10 x 7inches

Quality of image at 30 x 21inches

All about Image Size

This is the Image Size menu in Photoshop 7.0/CS

File size
This is the overall size of the image file in megabytes, ie 41.2MB.

Resample box
With this box ticked, when reducing or enlarging a picture Photoshop will automatically interpolate or resample the image to match what is set in the resolution box. When the image size is changed and the resolution kept the same, pixels are lost when the image is made smaller and pixels are added when the image is enlarged.

Measurements
The document size can be set in various measurements including inches, centimetres and pixels.

Maintain the size
Have this box ticked and when one image dimension is altered the other changes automatically to maintain the same image dimensions.

Interpolation style
Bicubic interpolation is the default resampling mode and it is this method that gives the best results when increasing image size.

Image Size

Pixel Dimensions: 41.2M
Width: 3000 pixels
Height: 2400 pixels

Document Size:
Width: 10 inches
Height: 8 inches
Resolution: 300 pixels/inch

☐ Scale Styles
☑ Constrain Proportions
☑ Resample Image:

Nearest Neighbor
Bilinear
✓ Bicubic
Bicubic Smoother
Bicubic Sharper

OK
Cancel
Auto...

Resolution matters
For web use, a resolution figure of 72pixels/inch is fine while for a photographic quality print you will need a higher figure, with 300pixels/inch usually quoted.

Pixel count
The figures here are related to the resolution and document size. For example, the width of 3000 pixels is 10 inches multiplied by the resolution.

interpolation delivers the best image quality when resizing photographs but it is also the slowest method. In this mode, new pixels are created after Photoshop has read the neighboring pixels, vertically, horizontally and diagonally.

Photoshop CS has two more variants on normal Bicubic interpolation, Bicubic Smoother is advised for enlarging images and Bicubic Sharper for image down-sizing.

Making big prints
However, if you want to make A4 or even A3-size prints at a true photographic quality resolution from images from 3, 4 or even 6 megapixel cameras interpolation is unavoidable and from my experience, any drop-off in image quality is remarkably minor. I think that goes to show how skilled editing softwares such as Photoshop and Paint Shop Pro are at this complex process.

I have read that when making extreme changes in image size, that doing this in stages rather than in one single big step optimises image quality. Equally, I know experts who are happy to achieve the image size change in one go. I suggest you try the options for yourself. If interpolation is really important to you try interpolation softwares such as Genuine Fractals, Extensis SmartScale and Shortcut S-Spline PRO.

Unsharp masking

The last step in the digital workflow is to add an Unsharp Mask. You can control the sharpening and it will make an amazing difference to your final print.

Using the Unsharp Mask filter to make pictures sharper sounds a contradiction, but of the various sharpening filters available, this is the one to use. Call up Photoshop's Sharpen menu and you will see several options but the one to use is the Unsharp Mask (USM). Sharpen, Sharpen Edges and Sharpen More are preset filters with none of the flexibility and control of the USM.

The Unsharp Mask concept comes from conventional photography and involves sandwiching the sharp negative with a slightly out of focus copy created from the original. Making a print from this combination gives a result that has greater contrast at the edges and thus an apparent improvement in sharpness. Photoshop's USM works on a similar principle but, of course, it is done digitally.

Most prints will benefit from the addition of the USM and it should be the very final step in the image-editing process because adding an USM can introduce artifacts or enhance any noise present. Too much USM will look horribly noisy.

Finally, do not make the mistake of thinking that the USM will rescue a poorly focused or blurred picture. You should always aim for good camera technique and the sharpest possible picture.

Where to find Unsharp Mask
Photoshop 7.0/CS
Filter→Sharpen→Unsharp Mask
Elements 2.0
Filter→Sharpen→Unsharp Mask
Paint Shop pro 8.0
Adjust Sharpness→Sharpness→Unsharp Mask

All about the Unsharp Mask palette

This is the Unsharp Mask dialogue box in Photoshop 7.0/CS

Preview window
Click on the image and you will see the 'before' effect. You can zoom in and out of the image by using Ctrl with the '+' and '-' keys.

Amount
The intensity of the USM is controlled here. I go for an amount between 50% and 150%. The trick is not to overdo it because the result can look dreadful. Vary the Amount in conjunction with the two slider controls.

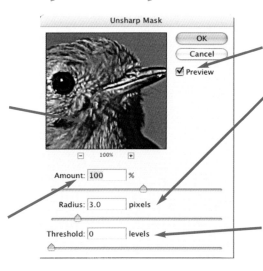

Preview
Have this box ticked so that you can see the effect of the USM in the preview window.

Radius
This control affects the width of the sharpening effect and the recommended setting is 1-2 pixels.

Threshold
Setting a higher Threshold means the USM will only be applied to neighbouring pixels that are significantly different in tonal brightness. Stick to a low value.

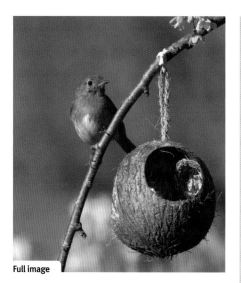
Full image

Step-by-step

Try sharpening in Lab Mode so that you only affect the black & white tones in the image. This avoids any colour fringing problems.

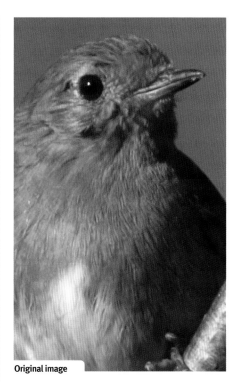
Original image

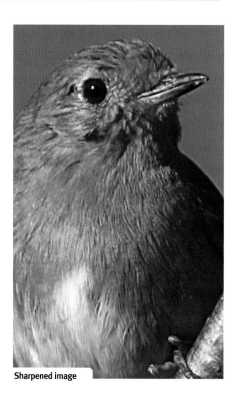
Sharpened image

Step 1 Convert to Lab color

Change from RGB Color to Lab Color by going to Image>Mode>Lab Color.

Step 2 Work on Lightness

Click on the Channels palette and click on Lightness to make this active. You will see the image in mono.

Step 3 Add the Unsharp Mask

Go to Filter>Sharpen>Unsharp Mask and sharpen the mono image. When you have done this, click on Lab to return to the colour image and reconvert to RGB.

Understanding Layers

It's very frustrating when you have a stunning sunset with a dull foreground or vice versa, but with the power of Layers you can bring two images or more together. And that is only one use for Layers.

The original sunset was photographed on a Nikon F801s with a 1000mm mirror lens. Obviously, you have to be very, very careful when looking directly at the sun through a camera. With such a long lens, looking at the sun could cause irreparable eye damage but on this occasion the sun was greatly diffused. Even so, with the camera on a tripod, I focused and composed very quickly then shot with my eye away from the eyepiece.

The bridge shot on its own was dull but I knew it would look good combined with a strong sunset.

Start images

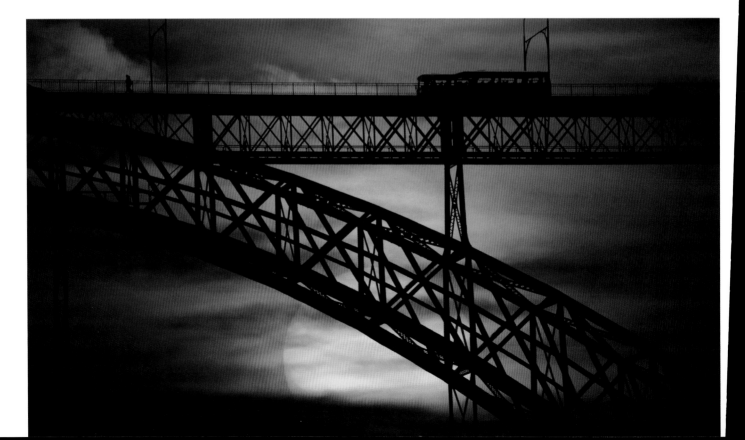

Step 1 Open both images

The sunset image looked fine but I decided to make the bridge shot a proper silhouette. Start by calling up the Levels menu using Enhance→Adjust Brightness/Contrast or Ctrl L. Select the right eyedropper and place the dropper on the sky before single-clicking to make it white. Next, select the left eyedropper and pick the area you want to be perfect black. This makes a silhouette.

Step 2 Combine the images

Select the Move Tool in the toolbox or press V. Click on the sunset and drag it onto the silhouette. Holding down the Shift key at the same time will place the sunset at the centre of the bridge image, but as the images are different sizes there is no point.

Step 3 Work on the sunset

With the Move Tool, move the sunset until it covers most of the bridge. There's a slither of bridge peeking through at the bottom. Make life easier by clicking on the bottom right of the image to give you more canvas to work with, then go to Image→Transform→Free Transform or Ctrl+T. Move the cursor to the bottom right of the image and hover. You see a double-ended arrow, click on this and pull the image out to over the bridge shot. Press Enter to confirm the transform.

Step 4 Make the silhouette

Call up the Layers menu with Windows→Layers. Click on Normal and you see a whole array of blending modes are offered. Scroll down and click on Multiply and you have a bridge silhouetted against a great sunset. Finish off by going to Layers→Flatten Image.

Health warning! Shooting the sun

Never stare directly at the sun through an optical instrument like a camera. Doing this can cause irreparable damage to your eyes. If you want to shoot sunrises/sunsets, do so when the sun is greatly diffused by clouds or atmospheric haze or shielded behind something.

Selections

If you really want to take control of your images, time spent getting to know the selection tools is well worth the effort.

Selection tools, and there are several of them, let you accurately isolate specific areas of the image, so you can keep close control of your editing. They allow you to define an area within an image and this area is shown by a border of 'marching ants'.

Certainly to start with, they can be frustrating tools to use. You can spend ages making a selection and if you unintentionally click outside the selection with the tool all your hard work vanishes. If this happens to

you, all you need do is go to Edit>Undo, use Select>Reselect, press Ctrl+Z or use the history palette. But for newcomers to selections there will an instant of blind panic.

In Photoshop 7.0/CS, there is a Quick Mask facility which lets you check your selection and this is definitely worth using. With your selection made, pressing Q brings up the Quick Mask, which is a bright red, and pressing the same key again takes you back to the active selection.

Lasso Tools

To use the standard Lasso, just click down on the mouse and draw around the area to be selected. As soon as you release the mouse, the selection you have made is automatically joined up to the start point.

With the Polygonal Lasso Tool, click once to start a selection, draw out a straight line with the mouse and click again before making another straight line and so on. Complete the selection by double-clicking or returning to the start point and single-clicking. This tool works well; just take your time and drop plenty of anchor points. Also, pressing and holding the Alt key turns Polygonal Lasso back a standard Lasso Tool.

With the Magnetic Lasso Tool, click on the mouse and drag the cursor close to the area you want to select, and this Lasso will automatically detect an outline and do the selection for you. That is the theory and it does work well with boldly defined objects but it is less effective in other instances.

Magic Wand Tool

This makes selections based on the luminosity values within the channels. If you have a red rose against a green lawn, clicking on the rose means the Magic Wand Tool will select all the red tones.

This tool does work well but you will have to adjust its tolerance settings to modify its sensitivity to the level you want.

Marquee Tools

While the Lasso Tools let you make freehand selections, the Marquee Tools allow you to draw specific shapes, although these can be varied and modified and used in combination with other tools. Their names are self-explanatory and selections can be modified using the Shift (adding to) and Option (subtracting from) keys.

Step-by-step

It was a very dull day when I took this detail shot at the Brandenburg Gate in Berlin. I thought using the Magic Wand selection tool and working on the sky would make it a much more effective image.

Original image

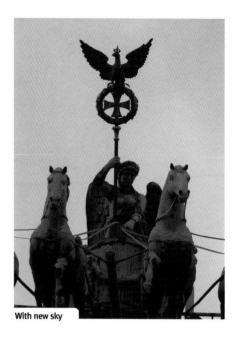
With new sky

Step 1 Select the sky

I set a tolerance of 32, and had the Anti-aliased and Contiguous boxes ticked. Ticking the Contiguous box ensures only neighbouring pixels are selected. Placing the Magic Wand Tool over the area to be selected and pressing the Shift key means the selection can be added to.

Step 2 Feather it

With all the dull sky selected, feather the selection. Go to Select→Feather. A small amount is needed just to make any 'join' less obvious. I put in 2 pixels.

Step 3 Add colour

Go to Image→Adjustments→Hue/Saturation or shortcut Ctrl+U. Tick the Colorize panel. Then it was the matter of adjusting the sliders to get a realistic looking sky. Click OK when happy and Deselect with Ctrl+D

Filter fun

Most manipulation softwares have built-in effect filters. Some are gimmicky, some are useful and some are sheer fun.

The effect filters found in editing software are usually the first things to be explored. They are great fun, but often that is far as photographers get, which is a pity because used with the right image the

Original image

results can be very effective. I took a picture of an eye to show just a few of the effects possible. The point to remember, apart from careful picture selection, is that using the filters at their default settings is often less effective than experimenting, so do have a play. Needless to say, do a 'save as' of the original file so that you do not ruin the original file.

Chalk & Charcoal

GO FILTER→ SKETCH→ CHALK & CHARCOAL
Pick a bold subject and this filter gives wildly graphic effects ideal for images destined for décor.

Coloured pencil

GO FILTER→ARTISTIC→ COLOURED PENCIL
It is worth increasing the Paper Brightness setting so that the base is light-toned.

Angled strokes

GO FILTER→BRUSH STROKES→ANGLED STROKES
All three settings are worth varying in this filter. The results can be excellent.

Diffuse glow

GO FILTER→DISTORT→ DIFFUSE GLOW
I love the effect of this filter. The result has a lovely, cross-processed feel.

Extrude

GO FILTER→STYLIZE→ EXTRUDE
A gimmicky filter that is fun too. Here the Depth setting was increased to 50 from the default 30 setting. Try some of the variables too.

Ocean ripples

GO FILTER→DISTORT→ OCEAN RIPPLE
The effect is reminiscent of shooting through patterned glass.

Lighting effects

GO FILTER→RENDER→ LIGHTING EFFECTS
This is definitely a filter well worth exploring. It is incredibly versatile but you need to sit down and spend time on it.

Radial

GO FILTER→BLUR→ RADIAL BLUR
Vary the settings to get an effect like a lens that has been zoomed during the actual exposure.

Noise

GO FILTER→NOISE→ ADD NOISE
Replicate film grain effects with this useful filter. Tick the Monochromatic box and try Uniform and Gaussian options.

Watercolor

GO FILTER→ARTISTIC→ WATERCOLOR
This effect works well with a detailed image. Try varying Brush size and Shadow intensity until you are happy.

Magnificent panoramas

Stunning views are ideal for the panoramic treatment, so the next time you are confronted by a majestic vista, take pictures to suit.

The view over Waddington Bay in Antarctica was something very special and I realised that there was no way the majesty and splendor of what was in front of me could be summed up in a single image.

I decided to take a series of five images to 'stitch' together. I did not have a tripod available so had to handhold the camera, a Canon EOS 10D fitted with an 70-200mm f/4 telezoom lens set to 100mm.

I did a 'dry run' first and panned around my proposed panorama to make sure my shots would overlap and cover the scenic area I wanted to include.

Once I had the shots, I relied on Adobe Photoshop Elements 2.0 to do the rest.

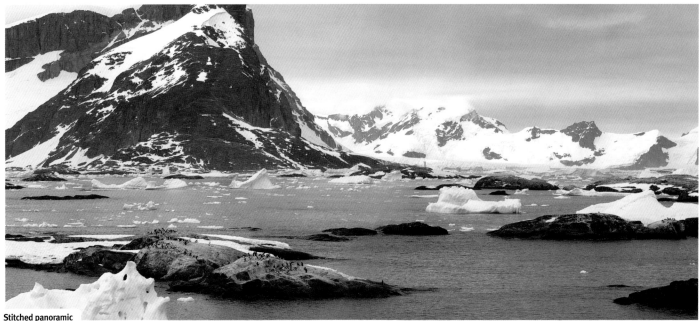

Stitched panoramic

This Antarctica landscape was originally photographed on a Canon EOS 10D with a 70-200mm zoom lens set to 100mm. It is important to ensure there is a decent overlap between each image to give a realistic effect.

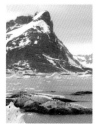

Start images

Step 1

MAKE A NEW DOCUMENT
Go to
File→New. The
document

was set to 300ppi and a size of 30x50cm gave plenty of room.

Step 2

CREATE PHOTOMERGE Go to File→Create Photomerge and click on Browse to find the required images. It helps if the pictures you intend using are stored in one place.

Step 3

SELECT YOUR IMAGES Choose your pictures and click Open. Pressing the Shift key and clicking on each file name means all the required files can be chosen in one go.

Step 4

PREVIEW THE PANORAMA Click OK and the software does the merge for you. If the software cannot handle an image it will tell you and the image can be merged manually.

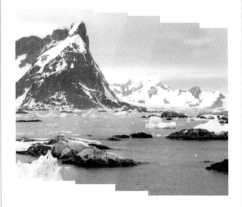

Step 5

THERE YOU HAVE IT The software can do a great job but there was still work to be done.

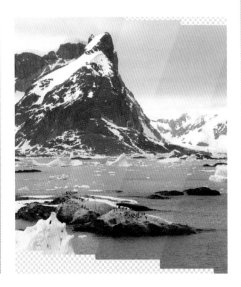

Step 6

CROP THE IMAGE Use the Crop Tool, or press the C key, and draw out the area you want cropped. Press Enter to confirm the crop. Once cropped, go to Layer→Flatten Image so that the several images become one ready for the next step.

Step 7

TIME TO CLONE The lines need to be sorted. Select the Clone Stamp Tool (or press S) and choose a big, soft-edged brush – mine was 175px – and reduce the opacity so the effect is subtle. Clone until there are no joins. ■

5 What to do with your images

Perfect prints

You have worked hard to get this far and you do not want to spoil your efforts by ending up with poor prints. The good news is that producing great prints is easy.

Use quality inkjet media for the best quality prints with good keeping properties.

The theory is simple. Connect the printer to the computer, open the document, follow the print dialogue and a few minutes later you are the proud owner of a masterpiece.

The reality, however, is somewhat different. The print might come out the wrong colour, the paper might have misfed so its surface is ruined or the computer might not recognise that a printer is connected at all.

Inkjet printing is wonderful and very convenient but it is not as simple or as straightforward as it is cracked up to be by the manufacturers. In fact, it can be intensely frustrating. Put another way, what can go wrong, invariably will.

There is a good choice of third party inks and it is worth experimenting with different types and brands.

Many people get image resolution and the printing resolution mixed up. Image resolution is exactly that and is measured in pixels per inch (ppi). To check the resolution of an image in Photoshop go to Image→Image Size. The generally accepted figure for true photographic quality image is 300ppi, although it is possible to go as low as 180-200ppi and still get excellent quality images. When you resize pictures for printing, consider 180ppi as the bare minimum image resolution.

When you go into the printer interface, you will see that you can print at different printing resolutions quoted in dots per inch (dpi). In the case of my Epson, resolutions of 360dpi, 720dpi, 1440dpi and 2880dpi are offered to the user.

The dpi figure is related to the number of minute dots of ink the printer squirts onto the paper and has nothing to do with the resolution of the actual image.

In short, the higher the dot count or dpi figure the finer the detail you will get in the print, but clearly you need a high resolution image in the first place. If the information is not available in the first place it cannot be transferred to the print.

Monitor set-up

Let us be honest. Everyone expects their prints to match what they see on the monitor, but I think this notion is worth kicking into touch. Not every delicate hue is possible in film and it is the same with digital.

You need to 'calibrate' or 'profile' your system and in my case, I have done that by getting to know how my kit performs by trial and error and building in corrections. By system, I mean from input (camera, film, scanner) to the computer (monitor, software) through to the output stage (printer, paper, inks).

Gadgets and devices are available to calibrate the monitor as well as the rest of the system, although personally I have not found a foolproof system.

When I make A3-size prints, one technique I use is to make small proof prints using the same ink and media as I would for the final prints. If the proof is not right I will make adjustments and try again until I am happy with the result.

Understanding print resolution

The original image had a resolution of 300ppi and a size of about 10x7inches. Interpolating in Photoshop the images were resized to just over 16ins on the long side at a variety of resolutions.

As you can see, there is little difference between the 200ppi and 300ppi images. The second row of images shows a high resolution 300ppi image outputted at a variety of printing resolutions.

Full image

Comparison of quality in ppi (pixels per inch)

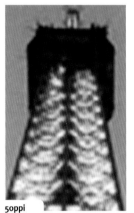
50ppi

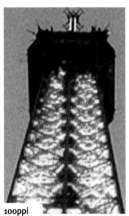
100ppi

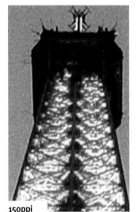
150ppi

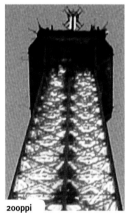
200ppi

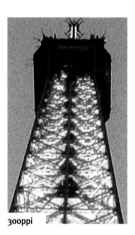
300ppi

Comparison of quality in dpi (dots per inch)

360dpi

720dpi

1440dpi

2880dpi

Make the perfect print

Thanks to the latest inkjet printers, taking control and making your own photographic quality prints has never been simpler.

Step 1 Resize the image

Go to Image>Image Size and resize the image to what you want. An image resolution of 300ppi is advised for true photographic quality. You can down to as low as 180ppi and still get excellent image quality. Ticking the Resample Image box means the software will resample or interpolate the image to match the desired size.

The Utility menu

Printing problems are relatively common so it is worth getting to know your printer's Utility menu. This is from an Epson Stylus Photo 1290.

The best form of maintenance is regular use. Infrequent use can lead to blocked ink nozzles, so even if you are not making prints, turn the printer on and let it go through its warm-up procedure.

If you experience blocked nozzles, use Head Cleaning followed by a Nozzle Check. Repeat the process if this does not resolve the problem.

Step 2 Select the print menu

Select print menu by File>Print with Preview, or Ctrl+P.

Step 3 Check orientation

This is an horizontal image but the paper default is upright. Click on Page Setup.

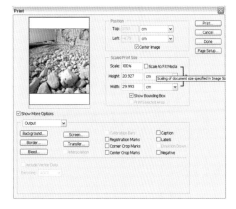

Step 4 Change the shape

In Page Setup, click on Landscape to give the correct orientation and click OK, which takes you back to the previous menu. Click on Print.

Step 5 Printer connected?

Clicking on Print brings up this menu, which shows the printer is connected and ready. Click on Properties.

Step 6 Exploring Properties

This is main Properties dialogue. Select Media Type and choose the type of paper to match what you are using, You will also see the amount of ink remaining in the printer cartridges. Click on Custom which makes the Advanced button active. Click on this.

Step 7 Set printer resolution

Media Type can be selected as well as printer resolution. For photo quality, a printer resolution of 1440dpi is fine. Colour, saturation, contrast and brightness can be adjusted in this dialogue. Click OK to confirm.

Step 8 Final step

You are now back at the main Properties menu. Click on the tab across the top. Paper, size, orientation and printing area can be adjusted. Click OK when you are happy to make the print.

Presentation

Taking photographs is great
fun but you will want to
show off your hard work too.
Here are some simple ideas
in Photoshop to spice up
your masterpieces.

Original image

Stroke

This feature of Photoshop 7.0/CS and
Elements 2.0 gives borders quickly. It is my
favourite way of producing simple borders.

Step 1 Call up the 'ants'
With the picture resized, select the whole
image with Ctrl+A. You will get 'marching
ants' around the image. Go to Edit→Stroke to
call up the Stroke menu.

Step 2 Define the border
Set the number of pixels to define the width
of the border. On an A3 print, I usually go for
6 pixels which gives a discreet thin border to
set off the image.

Step 3 Select the colour
Click on Color and the Color Picker dialogue
appears. I often opt for black but here I used
the eyedropper. Make sure Inside is picked
and finish by going to Select→Deselect.

Erase border

The Eraser Tool gives you the possibility of customised borders and it is very simple too. I thought this picture taken in a Milan cemetery would suit the rough border treatment.

Step 1 Select the Eraser Tool
Select the Eraser Tool, shortcut key E, and a brush of around 100 pixels and 100% Opacity. Click on the bottom right corner of the canvas and drag it down to give more room to work with.

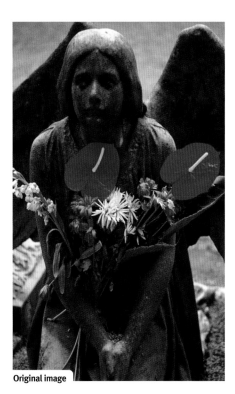

Original image

Step 2 Brush with care
Carefully rub around the edges to erase the image and give a blurred border. Work in stages so if you go wrong you can use the History feature and not have to revert all the way back to the original.

Step 3 Make a new document
Shortkeys for a new document are Ctrl+N and I went for an A4 size, 21x29.7cm, print. This is slightly larger than the prepared image and the resolution was set to match the image's.

Step 4 Move the image
Select the Move Tool, shortcut key V, click on the finished image and drag it across to your new document. Holding the Shift key at the same time ensures the image is placed centrally. Save the finished image and close the original without saving.

Presentation: Multi-image poster

I had the idea of a poster when I was taking pictures one autumnal afternoon at Westonbirt Aboretum.

The photography was simple, a handheld digital SLR and a macro lens set to a wide lens aperture. I knew each individual picture would be used quite small so I used fine quality JPEG mode but took my time waiting for the wind to drop before making each exposure. The light was constantly changing, which gave a lovely mix of different contrasts. I took about 50 shots, which I thought was enough to choose from, and got a great mix of colours featuring the same species of bush.

Step 1 Make a new document
The images were opened and had their Levels adjusted and then resized. I wanted an A1 size (59.4x84.1) poster with 25 images measuring about 10x15cm. I worked out the required size with some basic maths.

Step 2 Prepare each image
Each picture had a border added with help from the Stroke command (see previous page) and an Unsharp Mask was added. With the Move Tool (shortcut key V), click on each picture and drag them onto the blank document. Close each original after it has been moved.

Step 3 Arrange your shots
Keep on going until all your pictures are on your document and then start arranging your composition using the Move Tool. Make sure the Auto Select Layer box is ticked, which means that when you click and drag on a layer that is the one which is moved.

Step 4 Use the Grid
With your pictures in the correct order you need to accurately line the images up. Start by calling up the Grid in Photoshop by going to View→Show→Grid (shortcut keys Ctrl + apostrophe). Click on each image and move it into position. Go to View→Snap To→Grid which means the image will 'snap' to the grid lines and use the Ctrl and '+' key to magnify the image to see what is going on.

Step 5 Add a title
Select the Type Tool (shortcut key T) and tap in a title. Finally, when you are happy that everything is in the correct position go to Layer→Flatten Image so that the 27 layers become just one. Because I do not have a big printer I burnt my A1 poster to a CD and sent it to a processing laboratory for outputting.

The Colours of Autumn by William Cheung

Canvas effect

Go to Image→Canvas Size to call up the menu. Make sure Relative is ticked and tap in the width of the border required. Click on Background extension color to bring up the options menu. For a custom colour select Other. Use the eyedropper and pick an area in the image to select a colour for your border. I went for a mild blue here.

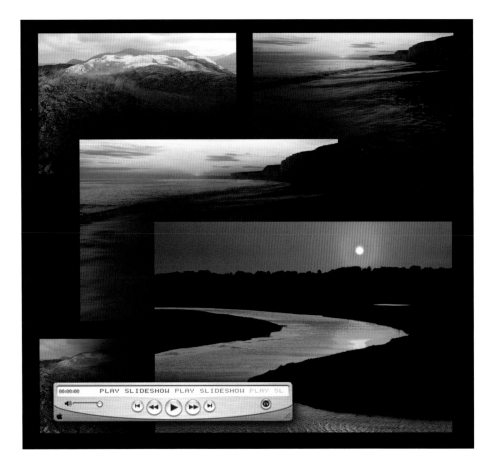

Step 1 Resize images

Decide which images you want and resize them to 72pixels/inch and 1024 pixels along the longest side. Save them as JPEG files and place them in a folder. Use Photoshop's browser to decide the running order and rename the images accordingly.

Step 2 Make a title slide

Leave one of the resized images open. I flooded it with black by hitting D and then Alt + Back space. The Type Tool was used for the title itself. Set White as the foreground colour by pressing D and then X. Tap in your heading, save and rename the image as Title slide. Make another slide to go at the end.

Digital slideshows

With the latest software producing your own audio-visual presentation is easy and results are very impressive.

An audio-visual show is a great way to present your photography skills. Simple presentations are one thing but making entertaining audio-visual shows is an art form in itself.

There are many different softwares that let you make picture shows set to music that you can burn to CD or DVD. A software that is very popular is PicturesToExe. This is PC only, costs $24 and can be downloaded from the website www.wnsoft.com

Step 3 Add pictures

Open up PicturesToExe (PTE) and locate your images. The file names appear on the left of the interface. Double click on each image starting with the title slide and going through the rest of them in the desired order.

Step 4 Add music

Click Project options and select the Music tab. Click the Add button and locate your soundtrack. Double clicking on the file will add it to your show. Remove the tick from Repeat music after playing.

Step 5 Set slideshow options

Next, click on the Screen tab. Tick the Display shadow behind the slide image box. A background colour can also be chosen to let your images stand out or you can use an image. Click on the Solid colour button or the Gradient filling and then on the folder icon to bring the Color menu.

Step 6 Set effects

Click on the Effects tab. Click on the two small empty boxes on the top right of the palette. This clears all the ticks set. Now tick only Fade in/out. There are many options available but I like to keep it simple. Experiment with the many options yourself.

Using music

Make a slide show with music from the latest best-selling CD and you will be breaking copyright law. The law says you must have the permission of the copyright owner before music can be used in this way. So, if you are thinking of presenting your work to an audience or sending out CDs, you will need to use copyright-free music. CDs featuring royalty-free are available off the Internet.

Step 7 Get synchronised

Click on the Main tab. Tick the Synchronize slideshow to music duration and PTE will automatically show each image for the same time. If you prefer, click Customize Synchronisation and you can decide transition points for yourself. Click Play and the music starts, then add transitions by clicking on the New Transition button. A blue arrow shows the transition and the grey area shows transition length.

Step 8 Preview your work

Click Preview to see what you have done. Go back to Project Options to tweak effects. Once happy, click on Create or go to File→Save.

The scanner as camera

The flatbed scanner is a versatile input device and you can even use it to digitise 3-D objects. Try it for yourself if you fancy images with a difference.

The flatbed scanner is so versatile as an input device that you can even use it as a 'camera'. In theory, you can connect it to a laptop and, with a long mains lead, venture outdoors, at least into the garden, for some in situ scanning. More practical, though, is laying three-dimensional objects on the platen and scanning them. This is fun and you can use the results in your photographs or create images in their own right.

Placing sharp objects on the sensitive platen surface might cause damage so do take care. A sheet of clear plastic, thin glass or even food wrap film can avoid this. An additional thin layer is no problem because there is plenty of depth-of-field and the object will still come out sharp.

You will not be able to close the lid properly so get round this by scanning in a darkened room or draping a sheet of cloth over the object and the scanning surface.

With the right mix of objects, fascinating images can be produced – and all without a 'real' camera.

Objects to scan

Everyday objects can be placed on the flatbed and scanned. To get you thinking of items to use in your compositions, here are some of things I have scanned successfully:

- Flowers and leaves
- Seashells and pebbles
- Scissors, cutlery and tools
- Parts of your body, such as hands and feet
- Fruit and vegetables
- Bric-a-brac, coins, medals and so on
- Textured materials such as wood
- Embroidery, textiles and cloth

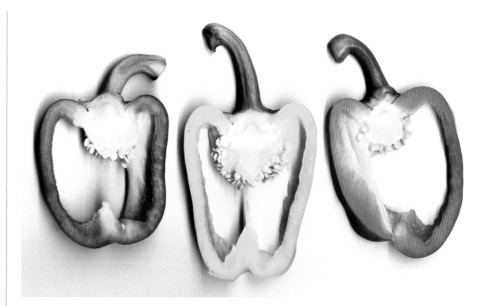

Step 1 Clean the platen

Use a soft, lint-free cloth and a glass cleaner to remove any dust, grease and fingerprints. With sharp or messy subjects, consider covering the scanner's glass plate with food wrap film or a thin sheet of acrylic.

Step 2 Position objects

Make the composition. Of course, this is less crucial because the objects can be cut out and manipulated in image-editing software. Drape a piece cloth – black velvet, white cotton – over the subjects.

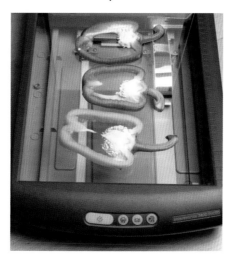

Step 3 Make the prescan

Do the prescan and make any necessary adjustments. Contrast, exposure and colour balance are the key things to check. Do another prescan and then, once you are happy, go for the full scan.

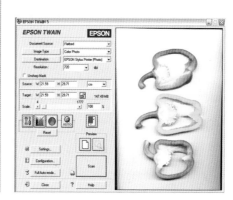

Make a DVD

Enjoying your pictures on the TV accompanied by a digital soundtrack is great fun, and with DVD players so common the chance to share your pictures is greater than ever before.

There are plenty of packages that will produce DVDs that can be played back on the typical DVD player. Earlier DVD players can mean compatibility problems, but generally the latest software will produce disks that work fine with modern DVD players.

As with many things digital, having a good idea of what you want to achieve in the first place helps. Most packages will have a series of templates varying from the tacky to the classy and tasteful.

In terms of skill needed, the good news is that most packages are really easy to use and it is just a matter of following a series of simple instructions. Many have 'wizards' to literally hold your hand through the logical process. Just resize and prepare your images and you are ready to produce your own audio-visual extravaganza.

Here I used Apple's iDVD 4.0, a program that lets you produce DVDs featuring video footage as well as still images.

Step-by-step

Step 1 Start a new project

Images do not have to be big – consider 640x480 pixels as a minimum. My images were put in a folder ready to import. With iDVD 4.0 open I went to New Project.

Step 2 Pick a theme

Most of the supplied theme templates are not to my taste, so I went for a simple portfolio-type template.

Tips for making DVDs

■ Make sure you buy the right sort of DVD disc to match your recorder/rewriter.
■ Buy copyright-free soundtracks to use with your shows.
■ Do not use the computer while the DVD is burning.
■ Keep to smooth, simple transitions rather than complex, over-fussy fades.
■ If there is a choice of backdrops, stick with a neutral colour such as grey or black. Vivid colours will detract from your images.

Step 3 Add slide shows

Click on Settings and tailor the DVD's opening interface. On this DVD I had images from four countries so I set up four slide shows, each labelled appropriately. Clicking on Customize brings up the dialogue box to personalise the picture show I was producing.

Step 4 Add the pictures

This is just the case of opening the folder and dragging your prepared pictures into the window and the software does the rest.

Step 5 Add sound

Click on Audio, locate your MP3 sound files and click and drag the required soundtrack to the Audio icon. Click on Sound Duration and select Fit to Audio, which means the software will automatically time image changes to the length of your soundtrack.

Step 6 Sort the transition

Decide how you want your pictures to fade into each other. Here, I went for a simple classic dissolve. Some softwares let you alter the speed and duration of dissolves.

Step 7 Preview and burn

Click Preview to check that everything works and that you are happy with the dissolves, the time delay between slide changes and the music. Once you are happy click on Burn.

Step 8 Add a front image

Pick an image as the entry image – this is how the DVD will look during playback and it is from here that you pick which presentation to enjoy. DVDs have plenty of capacity and you can make a great number of shows – just be considerate to the viewer!

Websites

The Internet is a huge opportunity. Not only is it an incredible resource for advice, information and ideas but it is also a huge on-line photographic gallery and everyone can show off their images.

There are many reasons for having a website. I must admit I was a 'late adopter' in this area but as more and more people have got access to the Internet, I thought it was about time I had one. Part of the reason I had not got a site together earlier was the thought that it would be involved and expensive.

Naturally, I was wrong on both counts. I bought a domain name from one of the many companies that offer this service as well as web hosting. I decided to keep my domain name simple and obvious, so I put in a request for williamcheung.com and a few variations thereof. The .com version was

taken but the .co.uk was available so I went with that. Domain name deals are constantly changing so get on the Internet for details, check out the specialist press or contact your current Internet Service Provider (ISP).

Next, I spent time on the Web and visited as many photographer sites as I could find. I figured that the best way to learn what makes a good-looking, user-friendly site was to check out other peoples'. I found many sites were slow to load because pictures were too big, or difficult to navigate with important stuff hidden away, or too word-heavy.

Get planning

With these factors in mind, I sketched out a site, which majored on galleries of images. My images were saved at screen resolution, 72ppi, and around 6x4inches so the file size was only 400KB or so. Then I added a brief biography, some picture-taking advice and a contact e-mail address.

With my pictures ready and the words done, I was ready to put the site together. There are plenty of books, software packages and websites that offer on-line design.

I took yet another option and asked a friend who I knew wanted to know more about web design and he used my site as a live learning experience. You may know someone in a similar position, or alternatively you could pay a web designer or have a go yourself.

Once the site was designed, all that remained was to upload it to the host

My home page: Clean and simple – just like me! I wanted my site to be easy to navigate so to enter you can either use the tabs down the left-side or click on my mugshot. And rather than have my images fighting with a bright background colour, I went for a neutral mid-grey which complemented rather than clashed and was gentle on the eye.

Birling Gap

Stunning chalk cliffs and a beach endowed with big pebbles makes this beauty spot on the English south coast a superb location. I spent two days there and didn't get bored for a moment.

My images: The gallery section is the heart (and the reason) for my site.

My camera gear

My gear: Photographers have an innate curiosity about cameras and what other people use.

10 tips

01

02

03

04

05

Hints and tips: The most wordy section of the site, but the information is delivered in bullet-point form.

following the detailed instructions provided. To be honest, although it was a slightly unnerving experience, it was not a difficult process. Similarly, updating and posting new sets of galleries is painless.

All in all, I am really pleased with the result.

■ My thanks goes to Ben Turner who designed my site using Dreamweaver. Visit my site on **www.williamcheung.co.uk** and I would love to hear what you think of it. Similarly, if you have a site that you are proud of, e-mail me the URL.

Useful web sites

Everything you need to know about setting up and promoting your website is on the Internet. Here are just a few sites to try:

■ **www.virtualnames.co.uk** Offers a domain name and web hosting service.

■ **www.Register.com** Big site with many services including domain names and web hosting.

■ **www.macromedia.com** Makers of Dreamweaver MX, a pro-standard web design software.

■ **www.cuteftp.com/cutesitebuilder/** CuteSITE Builder is a simple to use web design package.

■ **www.submitwizard.superstats.com** For a fee you can submit your site to over 200 search engines, including some of the most popular ones.

■ **www.yahoo.com** Offers hosting, domain names and much more.

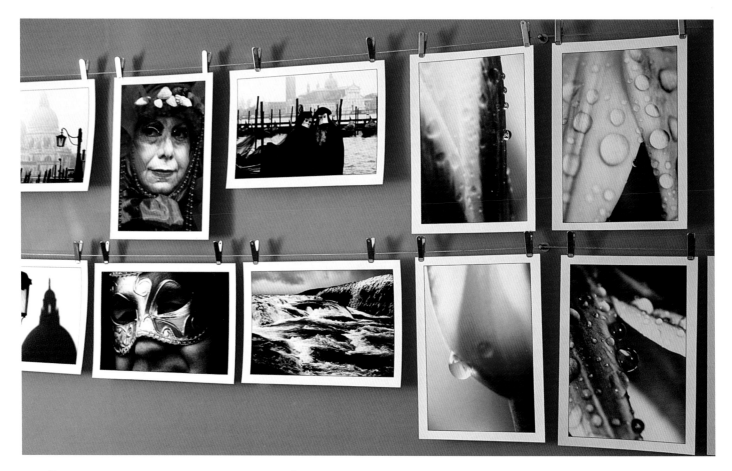

Picture decor ideas

Digital technology means that using your photographs to brighten up your life has never been easier.

Display your pictures

I got this idea for displaying pictures from a house style magazine. I bought a wire system for hanging up net curtains, fixed it up in the living room and found some attractive stainless steel clips to hold the prints. I now use this system for displaying and enjoying my latest inkjet prints. The beauty of this is that changing pictures takes seconds and the system is a focal point for visitors because the display is changing regularly. Having a gallery of one's own work is great for morale but it also means you are regularly assessing and appraising your photography. And you can guarantee that if you get bored with a particular picture in a few days, it is not worth showing friends.

Go for canvas

Have your digital images transferred to canvas and the print stretched over a wooden frame. The result is a three-dimensional print that can be very effective with striking images.

Blinded by your talents

A stunning landscape printed on a roller blind in the living room could look spectacular or a print of a child could personalize a bedroom. This approach would suit bold, well composed and colourful pictures.

Bag an image

Make very personal presents of your pictures by having them printed onto a bag like this. Pick strong pictures if you are going to have them printed onto a bag.

Inkjet media to try out

Visit a typical well-stocked photography shop and you will see a multitude of inkjet media for a wide range of different purposes. Here are a few unusual materials to try.

■ **Iron-on transfers** For making personalised T-shirts and creating your own unique curtain stencils.

■ **Transparent media** Potential here for lampshades as well as backlit displays of your images.

■ **Reflective papers** Another opportunity to use your images for interior décor.

Digital printing services

With the latest wide format inkjet printers, it is possible to get images onto all sorts of surfaces even carpets, glass, ceramics and fabrics. You can even have your own wallpaper produced featuring your best images. Here are a few websites to check out for digital printing services, but also ask your usual processing laboratory to see what they offer.

■ **www.maximaging.co.uk**
■ **www.carpetgraphics.com**
■ **www.loxleycolour.net**

Digital glossary

Jargon is common in photography and digital imaging. Sadly, jargon is inevitable so, rather than ignore it, here is a quick guide to many frequently used expressions.

A

ALGORITHM The process in a computer program used to solve or sort a particular problem.

ALIASING Aliasing is the jaggy edges noticeable in bitmap images featuring curves and diagonal lines. Anti-aliasing functions in image-editing software help to make aliasing less visible.

ALPHA CHANNEL Used for creating greyscale masks within an image and these can be edited using tools and filters. Alpha channel masks can be stored in Photoshop.

ANALOGUE Often used in imaging to refer to chemical or non-digital photography, ie film is analogue photography.

APERTURE The controllable 'hole' that lets light pass through the lens and measured in f/numbers or 'stops'. Wider apertures (f/2, f/2.8 etc) let more light through than smaller apertures (f/16, f/22) but gives less front-to-back sharpness called depth-of-field within a picture.

APERTURE-PRIORITY AE See Automatic exposure.

ARTIFACTS Flaws in a digital image. This can be noise within an image.

A-SIZES System of internationally recognised paper sizes. A5 is 14.8x21cm, A4 is 21x29.7cm, A3 29.7x42cm and A2 42cmx59.4cm.

ASPECT RATIO The relationship between the width and the height of a picture. Keeping the same aspect ratio means that this relationship remains constant when the image is reduced or enlarged. In Photoshop, the aspect ratio is adjusted via Image→Image size.

AUTOMATIC EXPOSURE (AE) Devices which can assess lighting levels and automatically expose for the situation. Scanners have autoexposure facilities but the expression is most commonly used in relation to cameras. The three most popular AE modes in cameras are: aperture-priority AE where the user sets the aperture while the camera sets a suitable shutter speed; shutter-priority AE is when the user sets shutter speed and the camera sets the correct aperture; and program where the camera sets both.

AUTO WHITE BALANCE Camera mode which automatically assesses the colour of the light source and corrects it to give accurate colour reproduction.

AV Shorthand for audio-visual.

B

BACKGROUND PROCESSING Allows the user to continue working on the computer while printing an image or document.

BARREL DISTORTION A lens distortion where straight lines near the edge of the picture frame appear bowing outwards.

BATCH PROCESSING This means applying a function or a series of commands to several files at the same time. This feature is useful when applying the same functions to a folder of images. In Photoshop, batch processing is found under File→Automate→Batch.

BI-CUBIC INTERPOLATION An excellent and effective method of image resampling or interpolation where the software assesses neighboring pixels to either side, above and below and diagonally.

BIT The smallest unit of computer information, which is ether 0 or 1.

BIT DEPTH This is the number of bits used to represent pixels in an image. 1-bit is black or white with no colours. Most image-editing softwares, scanners and cameras work in 8-bit, which gives (2x2x2x2x2x2x2x2) 256 shades of grey. 8-bit is obviously only one channel and this becomes 24-bit colour depth, ie 256x256x256, which gives 16.7 million colours. More and more camera and softwares, such as Photoshop 7.0/CS, are 16-bit compatible. A single channel in 16-bit gives 65,536 shades of grey and in 48-bit colour depth (65,536x65,536 x65,536) there are 281 trillion colours.

BITMAP Images made up of pixels are bitmap, thus all digital cameras produce bitmap files.

BRIGHTNESS Brightness levels range from 0 (pure black) to 255 (pure white).

BUBBLE JET Used by Canon to refer to their inkjet printers.

BUFFER The buffer is used by the digital camera to store pictures while they are being recorded or 'written' to removable storage media. A bigger buffer means more pictures can be taken in a single continuous burst. A smaller buffer means you end up waiting for the images to be stored to card. Consumer compact cameras have small buffers while pro-level SLR cameras will have a comparatively large buffer.

BYTE The standard unit of digital storage. One byte is made up of 8 bits and can have a value

in the range of 0-255. 1024 bytes is 1 kilobyte (KB), 1024KB is equal to 1 megabyte (MB) and 1024MB makes up 1 gigabyte (GB).

CALIBRATION Setting up a device – scanner, monitor, printer – so that it captures, displays or outputs images in an accurate way.

CANVAS The entire image on the monitor.

CCD Stands for Charge-Coupled-Device, a type of imaging sensor. Used in digital cameras, scanners and video camcorders. Relatively expensive and power hungry compared with CMOS sensors.

CD Compact disc and there are several variants. CDs can contain 650MB, 700MB or 800MB of data.
CD-R (recordable). These are inexpensive record once-only CDs.
CD-RW (rewritable). CD-RW discs can be recorded and erased over and over again. More expensive than CD-R discs to buy.
CD-ROM (read only). Software, for example, is supplied on CD-ROMs.

CMOS Stands for Complementary Metal Oxide Semiconductor and is a type of imaging sensor used in digital cameras. CMOS are an alternative to the CCD and said to be cheaper and less power-hungry.

CMS Colour management system.

CMYK A colour image mode made up of Cyan (C), Magenta (M), Yellow (Y) and Black (K). CMYK mode is used in the printing industry.

COLOUR CAST An image dominated by a single colour is said to have a colour cast. Colour casts are usually unwanted and can be removed in image-editing software. Casts can be avoided at the taking stage by setting the correct white balance mode.

COLOUR MODE The method used to represent the colours that an image contains. RGB, CMYK and grayscale are different colour modes.

COLOURSPACE There are methods of describing or creating a specific colour or tone. RGB, CMYK and LAB are different colourspaces.

COMPACTFLASH CARD The most popular camera media card currently in use. Available in Type 1 or Type II. Type 1 cards are flash memory so feature no moving parts. Type II cards house a tiny hard drive called a MicroDrive. Not all cameras will accept Type II cards because it is physically thicker; they are also potentially less robust than Type I cards.

COMPRESSION Files can be compressed so they take up less storage space or are faster to e-mail. Compression can be lossy, ie JPEG, or lossless, ie TIF. Lossy compression means information is discarded so regularly opening and saving a JPEG file will ultimately degrade quality. JPEG files can be compressed at different compression levels. TIF files can be made smaller using LZW compression.

CONTACT PRINT Small index print.

CONTRAST Contrast indicates a range of brightness within an image. A low contrast image has a small spread of tonal values of white to black while a high contrast image has a very wide tonal range. Contrast can be adjusted in image-editing software using either Levels or Curves.

DEAD PIXEL This is a single pixel that is always off and appears black in the image. It occurs at all shutter speeds. See also Stuck pixel and Hot pixel.

DECOMPRESSION The process to returning a compressed file to its full size.

DEFAULT Standard factory setting of a device or software. The default setting is not always the best and the user can usually alter to suit their needs, but there is usually an option to reset to default.

DENSITY Density value indicates how much light is blocked or absorbed by either slides or prints. A typical slide has a density of 3.0. Scanners are usually quoted with a density figure which gives you an idea of the density range it can deliver. A quality scanner will have a scanner density of around 3.8.

DIGITAL ASSET MANAGEMENT Jargon for looking after and organising your imaging files with a cataloguing software.

DIGITAL CAMERA An electronic, film-free camera that records images using a CCD or a CMOS sensor. Most digital cameras are highly featured and designed to be easy to use.

DIGITAL ZOOM A camera feature that crops and enlarges part of the main image to simulate an optical zoom. There is a loss of quality and an optical zoom is preferred.

DIRTY CHIP Dust and hairs on a camera sensor is known as a dirty chip and images will feature black faults. Follow the camera's cleaning instructions to get round the problem.

DISTORTION Zoom lenses can suffer from distortion. Barrel distortion means straight lines near the edge of the image frame curved outwards; pincushion distortion means straight lines curve inwards to give a pincushion effect.

DITHERING Inkjet printers and monitors use dithering to simulate many colours and intermediate values from just a few colours.

DNR Digital noise reduction. Random noise in images can be reduced or removed with a noise reduction mode in digital cameras. The process of noise reduction will slow down the procedure of writing files to the storage media.

DOWNLOAD The act of transferring files from one device to another.

DPI Dots per inch. Resolution of printers and monitors is usually quoted in DPI. DPI and PPI are often used interchangeably but this not technically correct. A photo quality inkjet printer can have a dpi resolution of 2880 or more. See also PPI.

DRIVER Software that allows an external device, ie scanner, printer, to be used with a computer.

DRUM SCANNER The sort of scanning device used by reprographic and printing companies.

DTP Stands for desktop publishing.

DVD Stands for Digital Versatile Disc. DVDs are widely used in the world of home entertainment, but they are very useful for imaging too. DVD disks are available in different formats. DVD-R, DVD+R, DVD+RW, DVD-RW, DVD-RAM and DVD-ROM. The R and RW stands for Recordable and Rewritable respectively and are the DVDs of most use to photographers. DVDs have a storage capacity of 4.7GB.

DYE SUBLIMATION A continuous tone printing method that gives true photo quality but running costs are higher than inkjet. Consumer dye-sub printers are also more limited with size output. Pixels are printed by a thermal print heads that vaporises the dye from a special ribbon onto dye-sub paper.

E

EPS Encapsulated Postscript.

EVF Electronic viewfinder. The viewing image is provided is a tiny LCD screen rather than through a traditional optical viewing system. The quality of the viewing image can be variable.

EXTERNAL HARD DRIVE A computer peripheral which gives more storage space. Worth having as a back-up and to keep your computer's hard drive relatively free of clutter. An external hard drive is connected to the computer via the FireWire or USB interface.

F

FEATHERING Feathering softens the edge of a mask or a selection so that when you montage or combine images together, there is no visible or obvious hard join.

FILE BROWSER A software tool that lets you view lots of low-resolution images at a time.

FILE FORMAT The way in which a digital image is stored. The main ones in imaging are JPEG, TIF, RAW and PSD.

FILM SCANNER Dedicated scanner for film images only. Most are 35mm but medium- and large-format scanners are also available.

FILTER There are on-camera filters and there are filters in software. Both are designed to alter or modify the image.

FIREWIRE Also known as IEEE-1394. This a connection interface with a fast data transfer rate of 400 megabits per second. A megabit is a million bits. FireWire 800 is even quicker at 800 megabits per second.

FLASH MEMORY Most storage cards are flash memory and can retain data without the need to be powered up.

FLATBED SCANNER Works like a photocopier with a light source that traverses the image to be scanned. Artwork, documents, film images and even 3-D objects can be scanned.

FOCAL LENGTH Every lens has a focal length. What is known as the standard focal length is roughly the equivalent of the diagonal of the film or sensor format.

The standard focal length gives a perspective that is akin to that of the human eye. Lenses that are shorter than a standard are known as wide-angle, and those that are longer are called telephoto.

In the 35mm film format, a standard focal length is generally accepted as 50mm.

The situation with digital cameras is difficult because focal lengths are much shorter, like 6mm or 12mm. This is why the manufacturers usually quote focal lengths as equivalent to the effect you get in 35mm film photography, which more people can relate to.

G

GAMMA The measure of contrast in an image or imaging device.

GAMUT The range of colours and tones that a device is capable of recording or reproducing.

GAUSSIAN BLUR A controllable and popular blur filter available in many image-editing software including Photoshop.

GB (GIGABYTE) A quantity of computer memory or disk space, ie 1024 megabytes.

GRAPHICS TABLET A computer peripheral that makes some aspects of digital imaging easier, ie making selections of fine detail. Instead of a mouse there is a special 'pen' and a touch sensitive pad.

GREYSCALE Or Grayscale. In digital speak, a greyscale image comprises black, grey and white tones.

GSM The weight of metric paper is measured in grams per square metre. For quality prints, paper around 260-300gsm is best.

H

HARD COPY Techno-speak for something you can handle, ie prints, as opposed to an image on a monitor.

HISTOGRAM This is a graphic interpretation of the tones in a digital image. A histogram function is available in many top-end digital cameras. In image-editing software, call up Levels and you will see a histogram.

HOT PIXEL This is a pixel that reads high on longer exposures and can appear white, red or green. The longer the exposure the more visible any hot pixels. Some cameras have a noise reduction software to minimize the effect. See Noise reduction and Stuck pixel.

I

IMAGE MANIPULATION SOFTWARE Image editing software such as Photoshop, Paint Shop Pro and PhotoImpact.

IMAGE SIZE Actual size of the image. In Photoshop CS this is found under Image→Image size.

INKJET PRINTER Peripheral for outputting prints. Inkjet printers work by squirting out miniscule droplets of coloured ink or dye onto specially coated paper. They come in different sizes. For the amateur photographer, A4 and A3+ printers are common.

INTERPOLATION Also known as resampling. Increasing image size means the image-editing software has to 'guess' to fill in missing colour information, which it does by looking at neighboring pixels. There are also dedicated interpolation softwares available, such as Genuine Fractals and Extensis SmartScale.

ISO In film photography ISO refers to the film's sensitivity to light. Lower speeds like ISO 100 are less sensitive to light but give the best image quality. Faster films are more grainy and colours less rich.
In digital photography, the ISO rating refers to the camera's sensor's sensitivity and is equivalent to the ISO scale used for film. The lowest setting is the sensor's true sensitivity and boosting is needed to achieve the higher ISO ratings. Boosting can result in digital noise, which is like a sort of digital grain.

J

JAGGIES Zoom into a low resolution image and you will see a jagged stepped effect of individual pixels. These are jaggies.

JPEG A popular file format that compresses images to smaller sizes that are more convenient to e-mail or store. JPEG compression is used by every digital camera. JPEG is a lossy format and each time a JPEG file is opened, edited and saved, information is discarded. This might not be obvious with a few saves as JPEGs, but do it 20-30 times and the drop-off in quality is much more obvious. The level of JPEG compression can be varied – the greater the compression (Level 1, 2) the greater the information loss and the smaller the file. A level of 10-12 gives larger files.

L

LCD MONITOR A small screen on the back of digital cameras which allows the reviewing of taken images. On compact cameras the monitor also allows composition.

LEVELS A really useful tool in image-editing software that lets you adjust 'exposure.'

LOSSLESS COMPRESSION See TIF.

LOSSY COMPRESSION See JPEG.

LPI Lines per inch. An expression used to indicate resolution. The higher the figure the better the resolution.

LZW COMPRESSION Lempel-Ziv-Welch. A popular lossless image compression algorithm used in saving TIF files.

M

MACRO Close-up photography is usually referred to as macro. Macro lenses are specially designed to focus really close.

MEGABYTE (MB) An amount of memory, 1024 bytes.

MEGAPIXEL One million pixels. A measure of camera resolution. Decent digital cameras are now a minimum of 3 megapixels while top-end models are 5-6 megapixels.

MICRODRIVE A tiny hard drive also known as a Type II CompactFlash card. Usually have a high storage capacity such as 1GB.

MPEG Stands for Moving Picture Experts Group. MPEG is a moving image digital compressed format. Many digital cameras can shoot MPEG.

N

NOISE Digital cameras used in low lighting results in long exposures and this can result in noise, especially in the shadow areas. More advanced digital cameras have a noise reduction software but this does slow down writing of images to the storage card.

O

OPTICAL RESOLUTION The actual non-interpolated resolution of an input device.

OPTICAL VIEWFINDER A viewfinder that uses a system of optics to provide the viewing image. See also EVF.

OPTICAL ZOOM See Zoom lens.

P

PCMCIA Also known as a PC card. Used to be popular as removable cards in laptops but now smaller cards like CompactFlash are being used and these slip into PCMCIA adaptor.

PICOLITRE One millionth millionth of a litre. Inkjet printers deposit minuscule drops of ink or dye during inkjet printing. Some modern inkjet printers have an output of two picolitres.

PIXEL PICture ELement, the smallest bit of a digital image. In an 8-bit RGB image, each pixel can be any one of 16.7 million colours.

PIXELISATION Where the pixels of an image are readily visible.

PLUG-IN A software that adds extra functionality to the main program. For example, Photoshop plug-ins are popular because more effects are possible.

PPI Pixels per inch. A measure of the resolution of digital cameras and scanners. The higher the figure, the better the ability to resolve fine details.

R

RAW FILES Top-end digital compacts and SLRs allow RAW file shooting for the best possible image quality. RAW files are recorded to the camera storage media with no processing or compression so are comparable to digital negatives. How RAW files are converted to JPEGs or TIFs is important and have a fundamental effect on the result. The disadvantage is that RAWs need processing in dedicated software, although programs like Photoshop CS are RAW compatible.

RESAMPLING See Interpolation.

RESOLUTION The amount of detail a camera, scanner or printer can reproduce. The higher the resolution figure the finer the detail that can be recorded. See PPI.

RGB A colour mode in which the image comprises red, green and blue light. RGB mode is used in digital cameras and scanners.

S

SCANNER Flatbed and film only scanners are available. The former can digitise photographs, documents and 3-D objects.

SHUTTER SPEED The length of time a camera shutter is open to allow an exposure is known as the shutter speed. See Aperture.

STUCK PIXEL A stuck pixel always reads high or is stuck on maximum for all exposures and produces a bright pixel, usually of red, green or blue. See Dead pixel and Hot pixel.

T

TELEPHOTO LENS A lens that has a longer focal length than normal so makes distant objects appear bigger or closer than they are. See also Focal length.

THUMBNAIL A low resolution preview image of a larger image file. A thumbnail can save you the effort of opening a large file.

TIF Tagged Image File Format. TIF files are suffixed with .tif and this is a lossless image compression system. See also LZW compression.

TWAIN Protocol for exchanging data between applications and devices.

U

UNSHARP MASK Often called a USM, this is a software filter that enhances contrast and thus effectively sharpens an image. The USM can be varied to suit the image.

USB Universal Serial Bus. This is the connection interface to attach peripherals including external hard drives to the computer. USB devices are hot-pluggable so you do not have to restart the computer for the device to work. The original USB 1.1 was slow at 12 megabits per second has now been superseded by hi-speed USB 2.0, which can (in theory) transfer data at a rate of 480 megabits per second.

W

WHITE BALANCE Digital cameras can electronically assess the lighting conditions to give the correct colour reproduction. Cameras have presets for different light sources, but you might prefer to take the automated approach. See Auto white balance.

WIDE-ANGLE Wide-angle lenses have a shorter focal length and thus a wider view than normal so are ideal for shooting in cramped conditions. Also see Focal length.

WYSIWYG What you see is what you get.

Z

ZOOM LENSES A lens with variable focal length that means you can change image magnification without moving. Zooms are available in a wide-range of focal lengths.

Acknowledgements

Publishing a book is very much a team effort so inevitably there are many people I would like to thank. Without Angie Patchell there would have been no Switch to Digital, so I must thank her for her enthusiasm and nagging (in the nicest possible sense) to urge me on, especially when the going got tough.

I hope you will agree with me that Switch to Digital looks great and this is solely the responsibility of the book's designer, Chris Robinson. I have known and worked with Chris for the best part of ten years and never once has he let me down. With his brilliant design in Switch to Digital his record remains intact.

I would not have got very far without the support of the camera manufacturers and UK photo distributors. So thanks to Elaine Swift, formerly of Nikon UK; Jane Nicholson of Intro 2020; Graham Armitage of Sigma Imaging; Robin Whetton of PermaJet; and an extra special thanks to Angela Mason-Warnes of Canon UK.

Finally, but by no means least, I want to say a huge thank you to my partner, Jo. Her unstinting support (and endless cups of tea) has kept me going and for that I shall be ever grateful.

Of course, thank you too for reading this and I trust you will enjoy Switch to Digital. E-mail me with any thoughts you might have on ‹willtherooster@hotmail.com›

I would love to hear from you.

William Cheung FRPS